SPOT THE DIFFERENCE GREAT ARTISTS

LOUIS CATLETT

SIRIUS

SIRIUS

This edition published in 2024 by Sirius Publishing, a division of
Arcturus Publishing Limited,
26/27 Bickels Yard, 151–153 Bermondsey Street,
London SE1 3HA

Copyright © Arcturus Holdings Limited/Louis Catlett

ISBN: 978-1-3988-3649-5
AD011759NT

Printed in China

CONTENTS

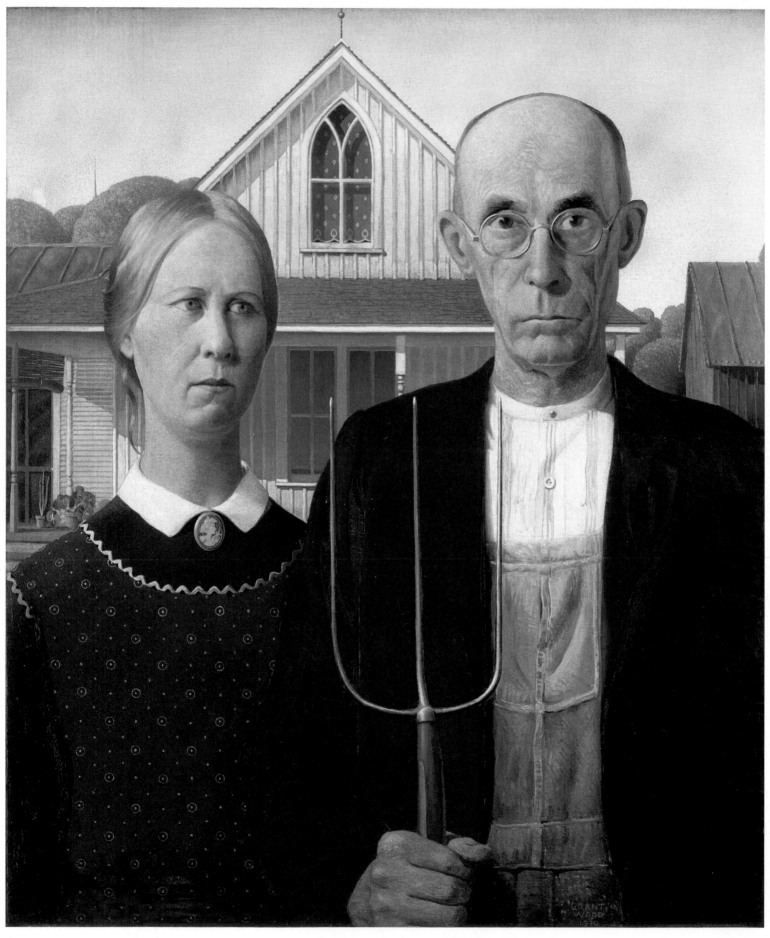

Grant Wood—*American Gothic*

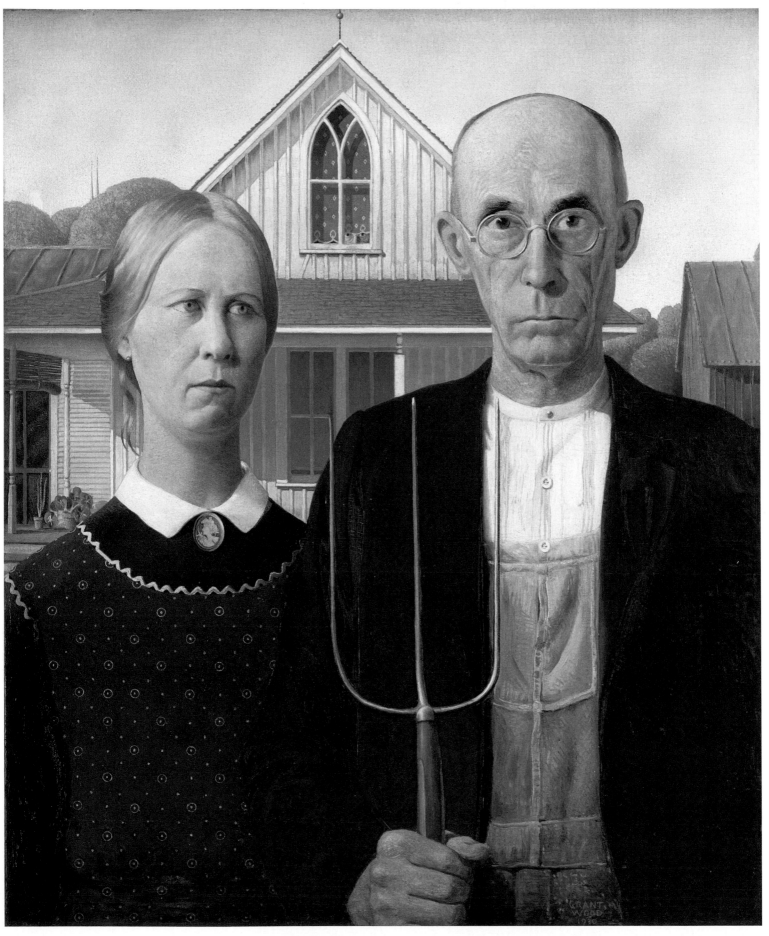

Number of differences: 14 Answers on page: 66 5

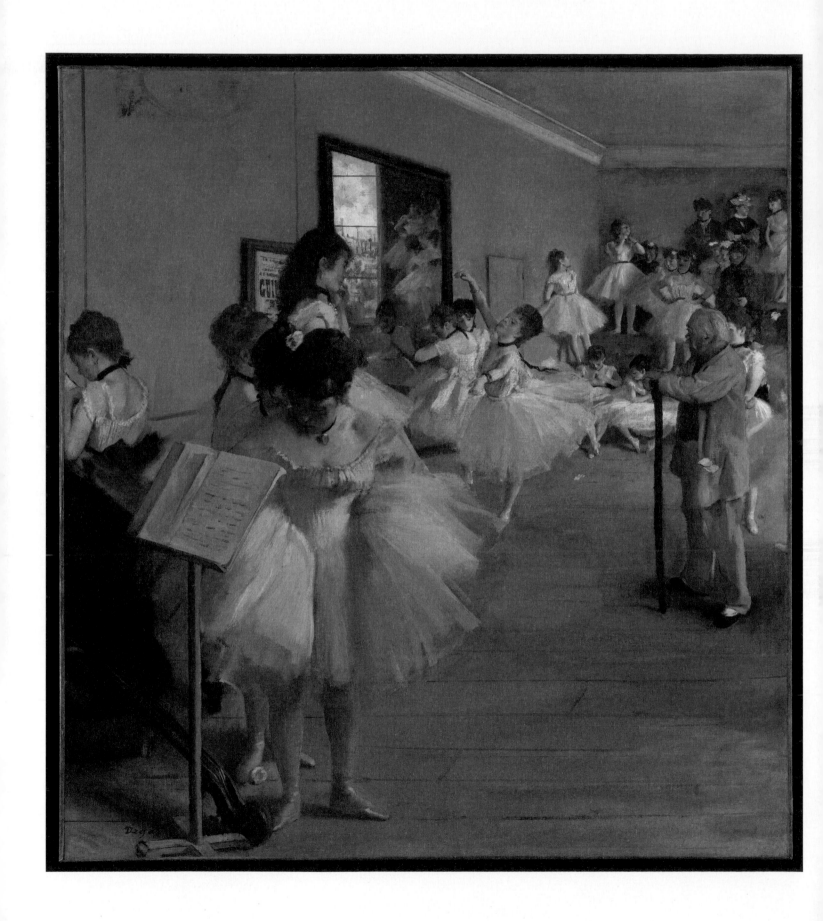

Edgar Degas— *The Ballet Class*

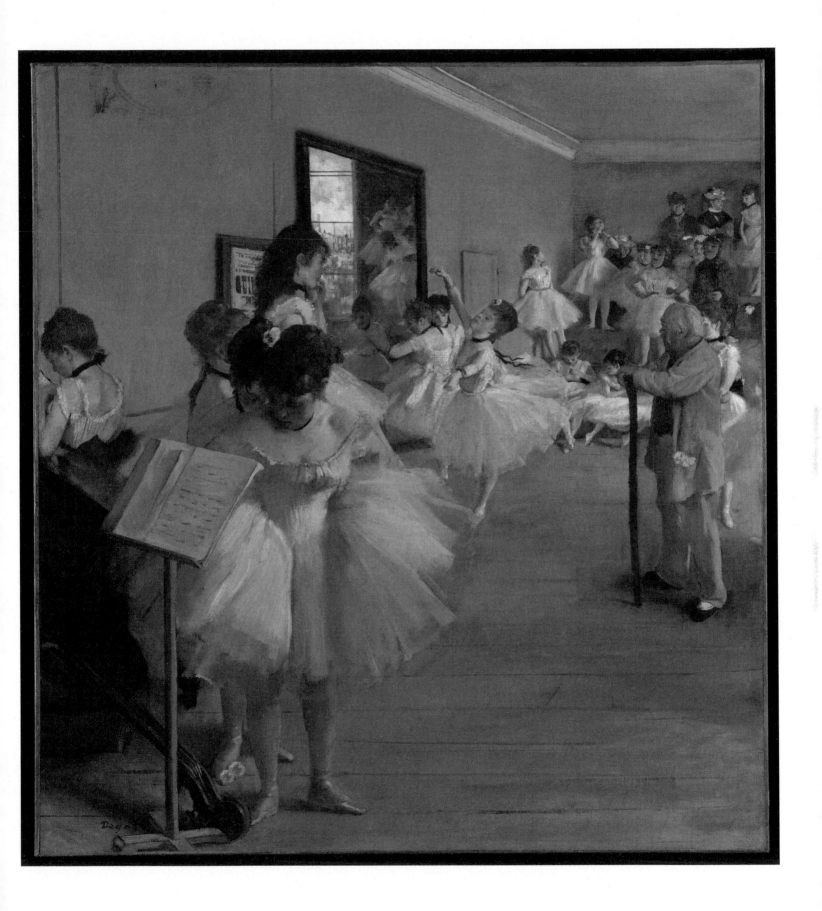

Number of differences: 14 Answers on page: 67

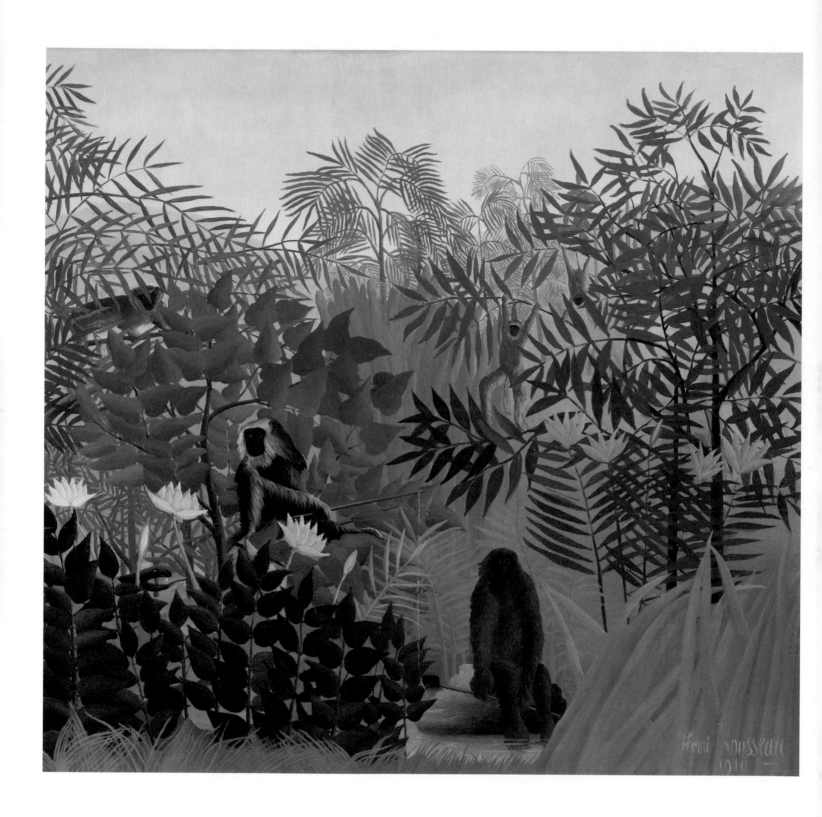

Henri Rousseau— *Tropical Forest with Monkeys*

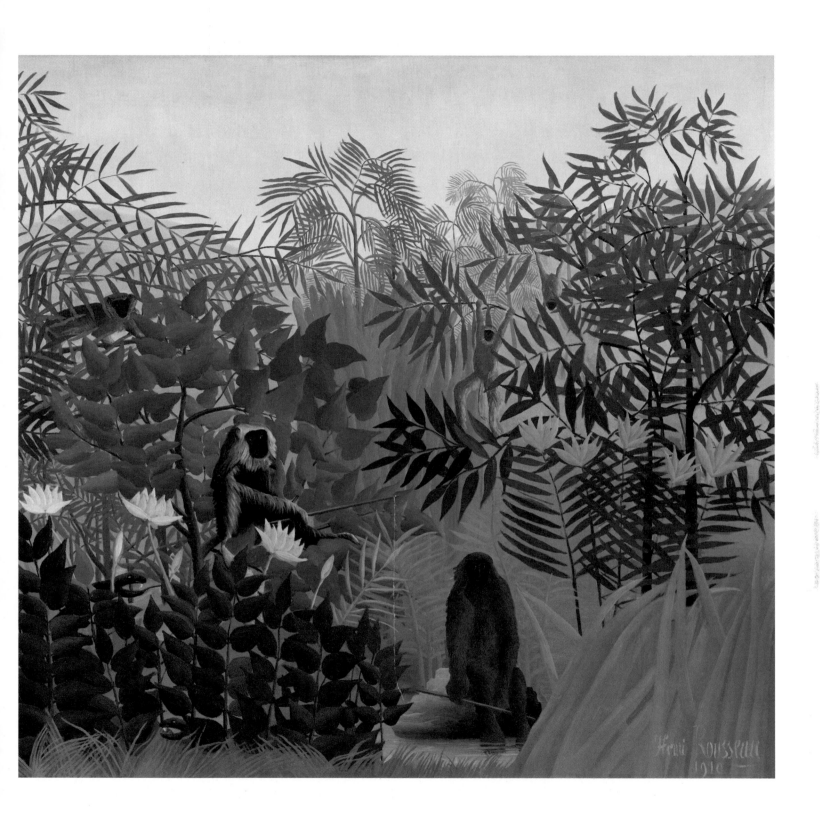

Number of differences: 12 Answers on page: 68 9

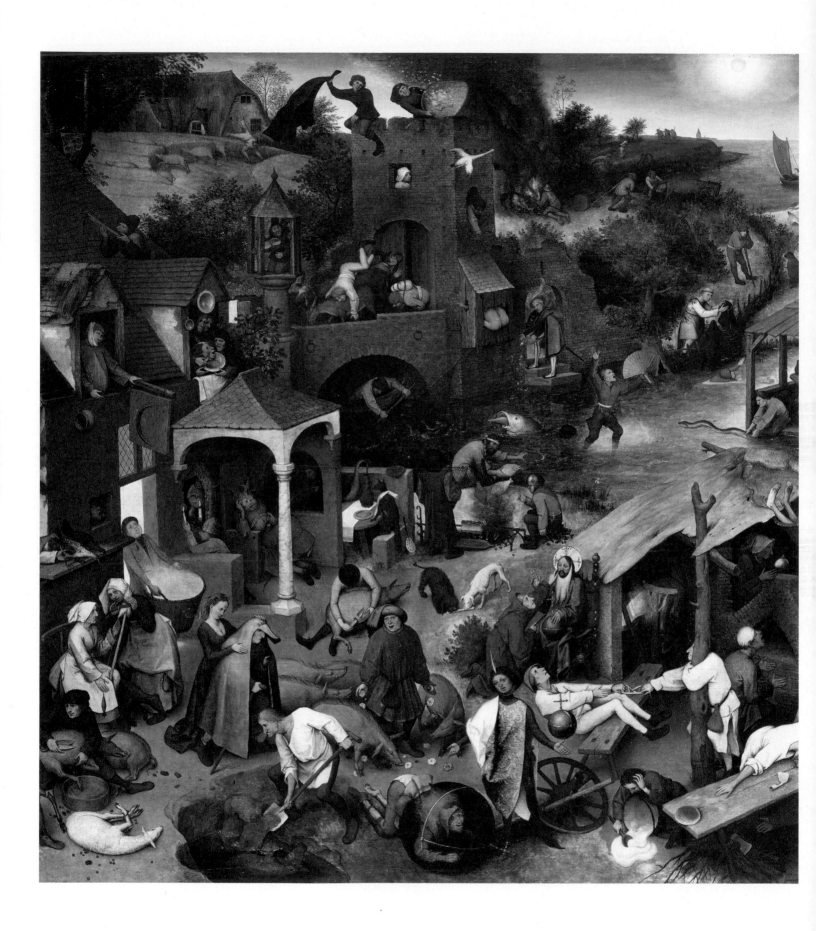

Pieter Brueghel the Elder — *The Dutch Proverbs*

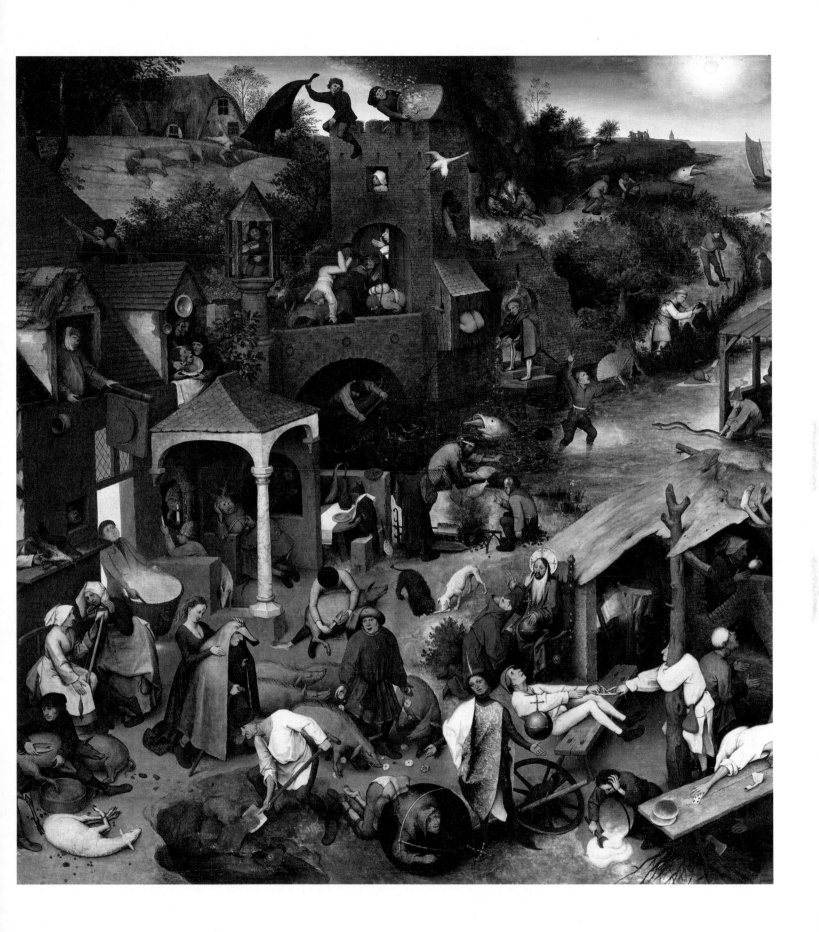

Number of differences: 18 Answers on page: 69 11

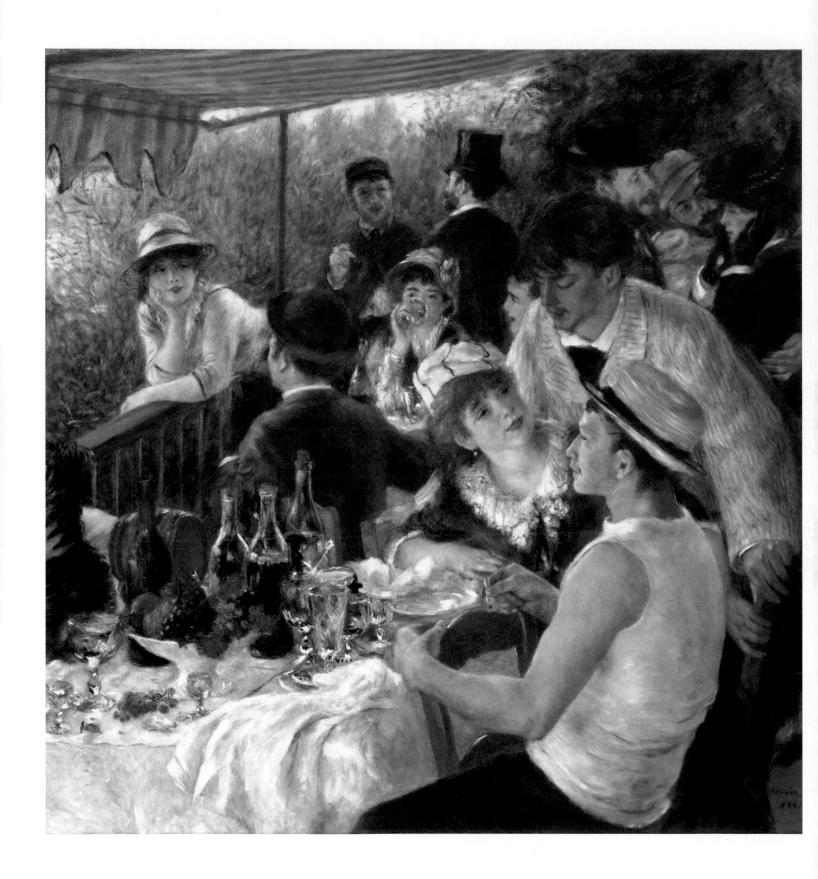

12 Pierre-Auguste Renoir—*Luncheon of the Boating Party*

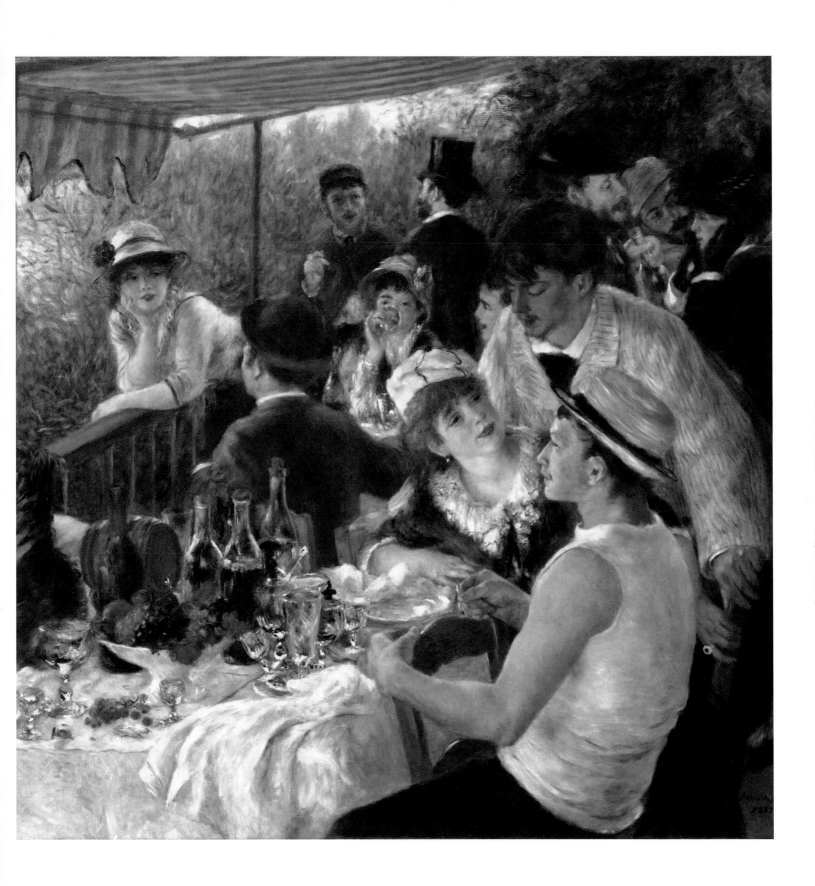

Number of differences: 14 Answers on page: 70 13

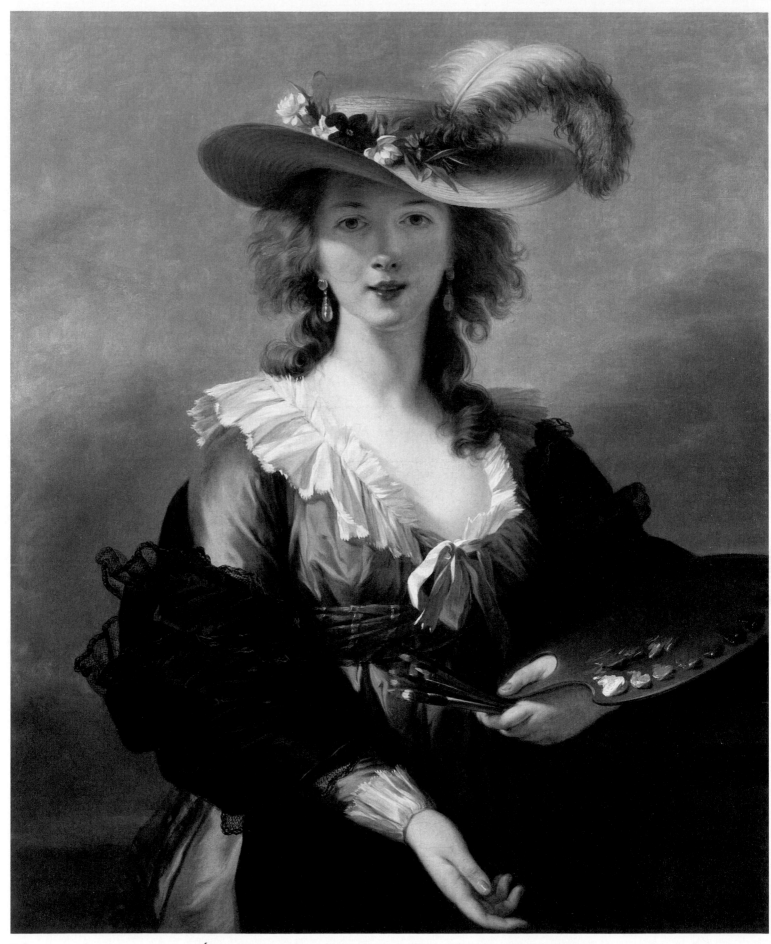

Élisabeth Vigée Le Brun—*Self-portrait in a Straw Hat*

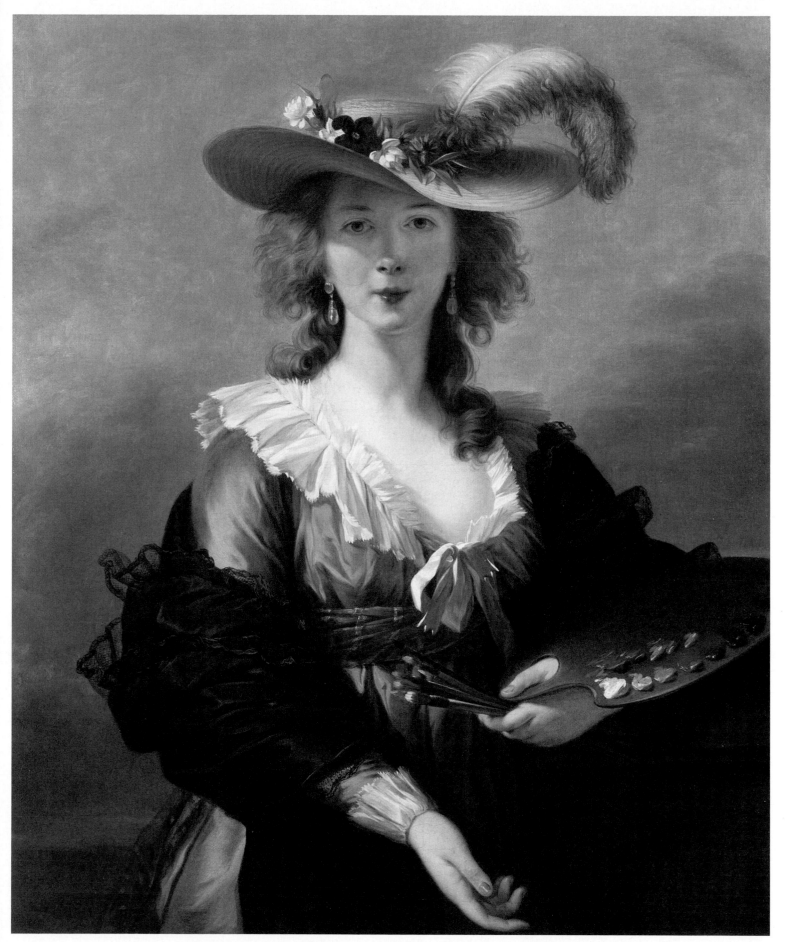

Number of differences: 13 Answers on page: 71 15

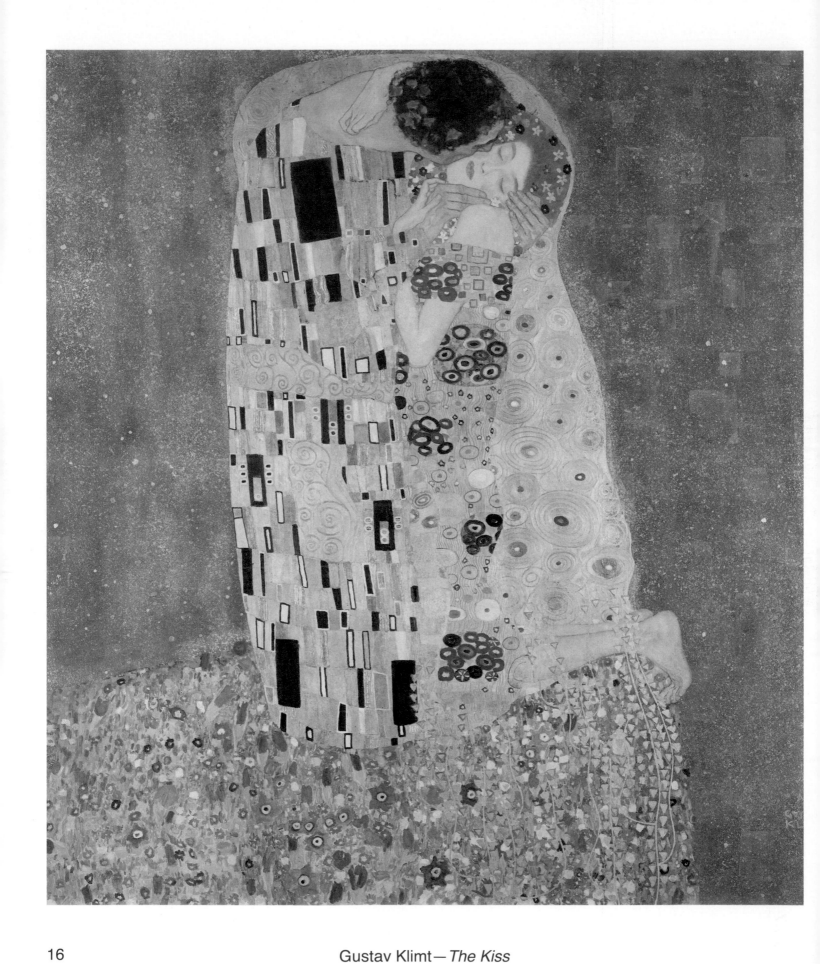

Gustav Klimt—*The Kiss*

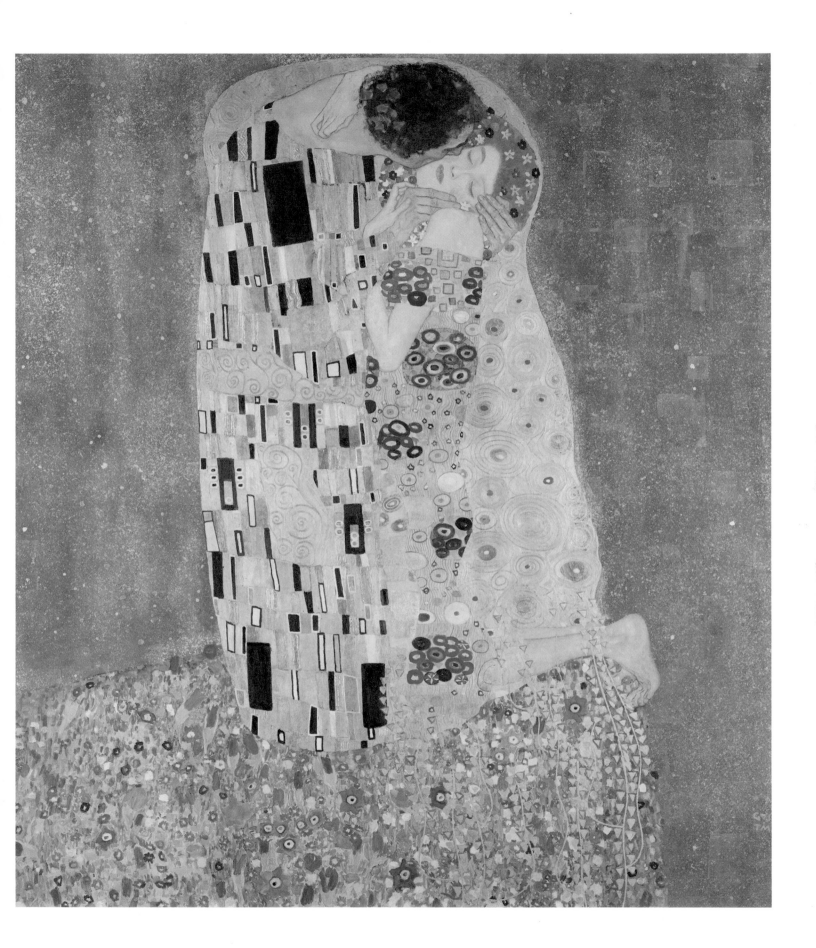

Number of differences: 14 Answers on page: 72

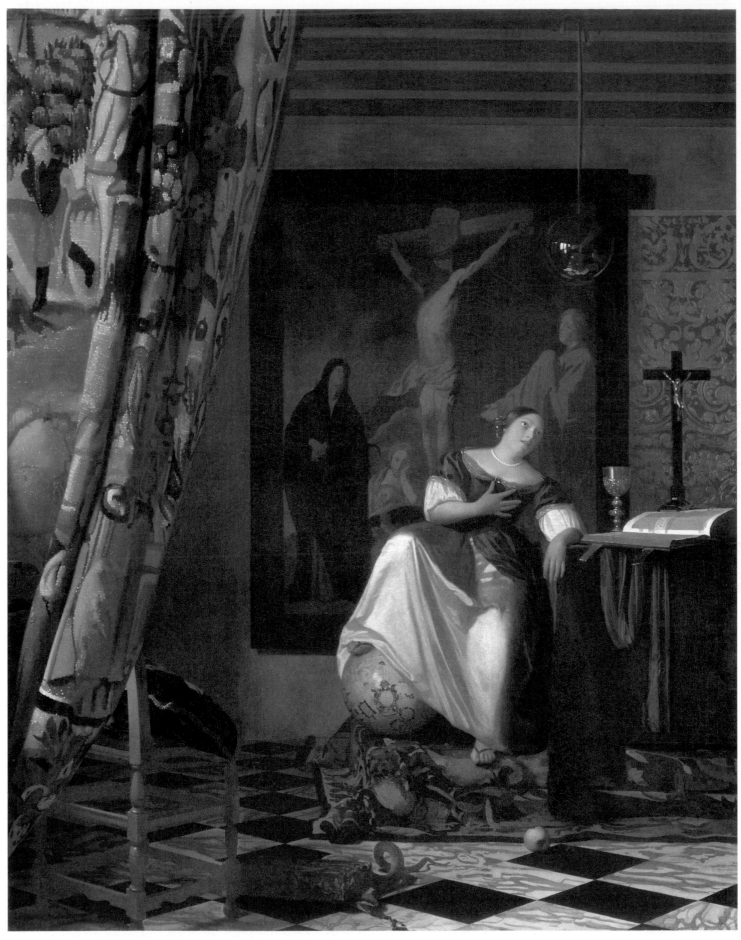

Johannes Vermeer — *The Allegory of Faith*

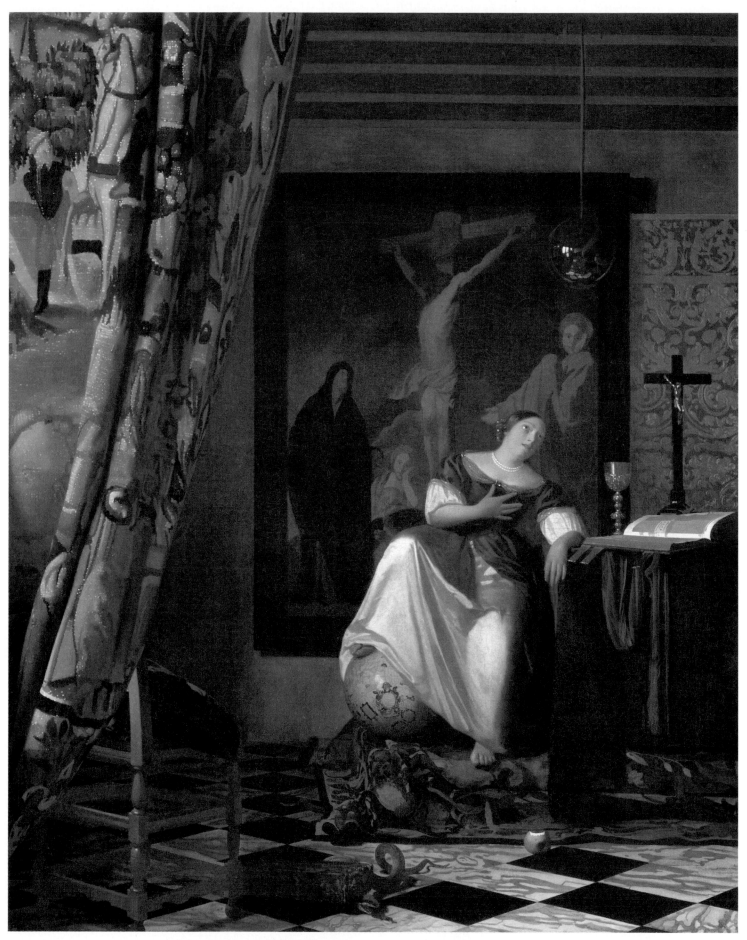

Number of differences: 17 Answers on page: 73

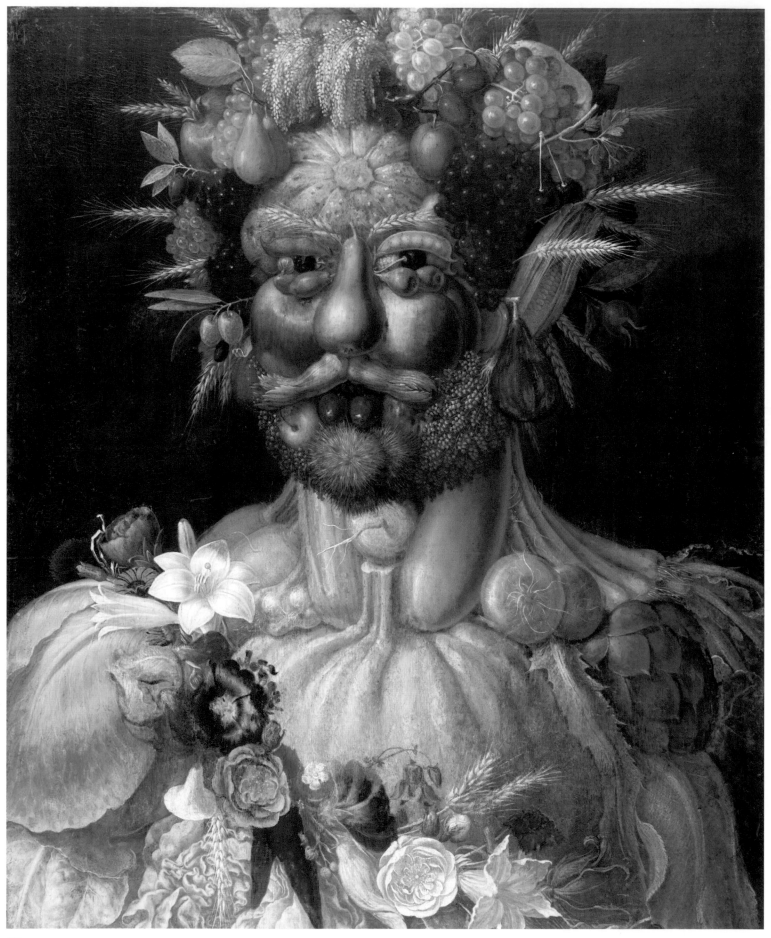

Giuseppe Arcimboldo— *Vertumnus*

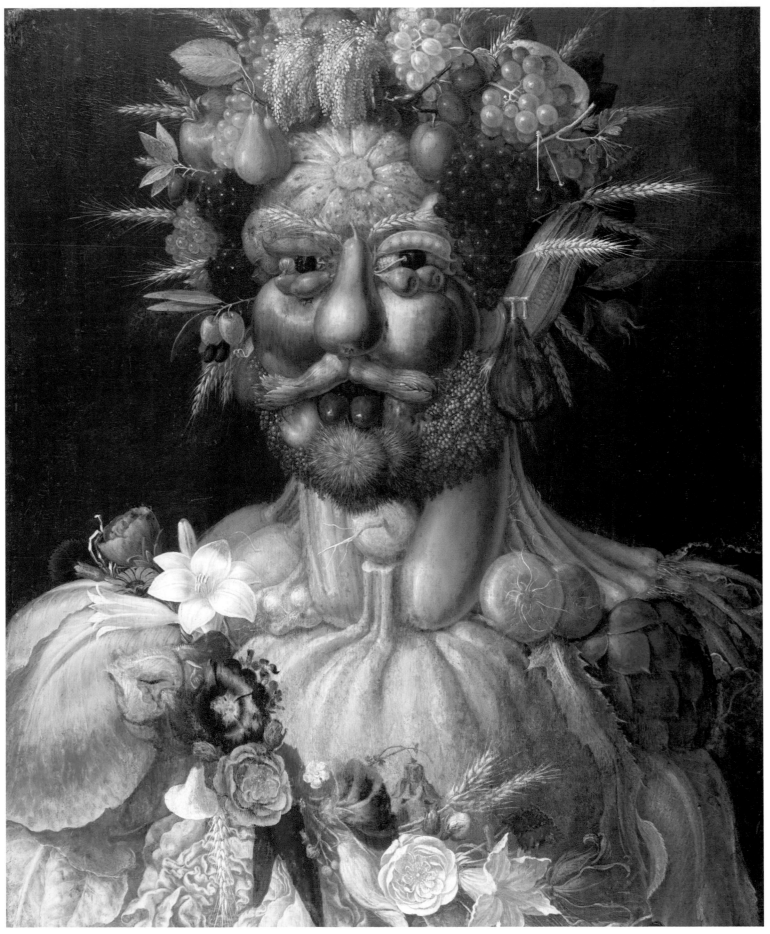

Number of differences: 11 Answers on page: 74 21

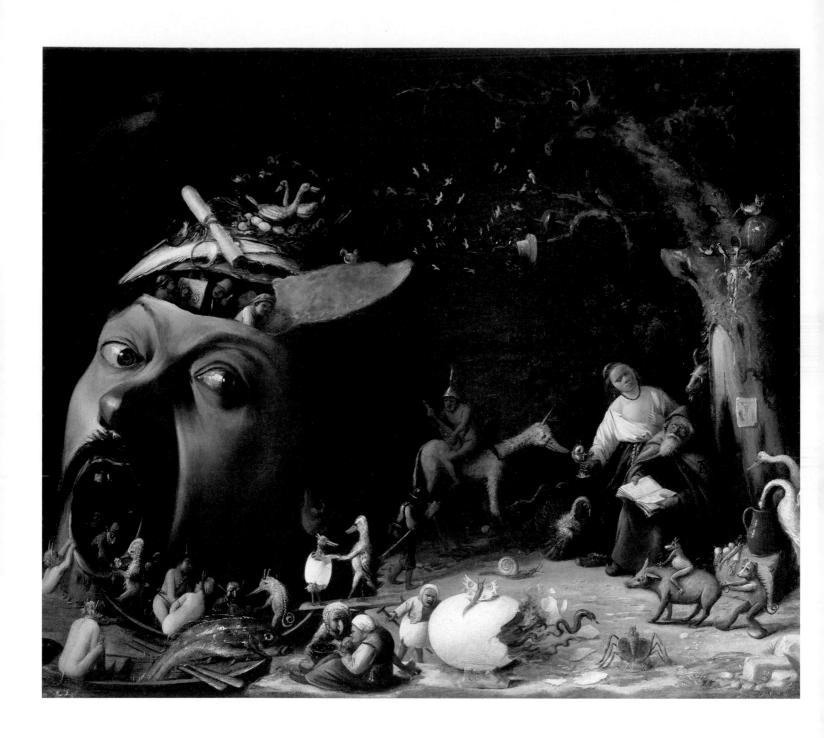

Joos van Craesbeeck—*The Temptation of St. Anthony*

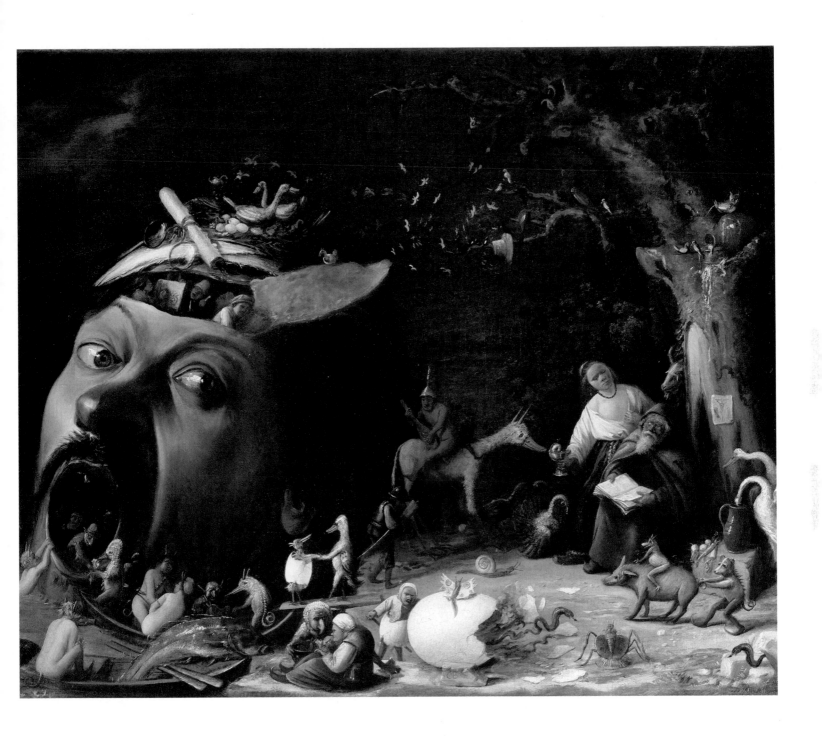

Number of differences: 16 Answers on page: 75 23

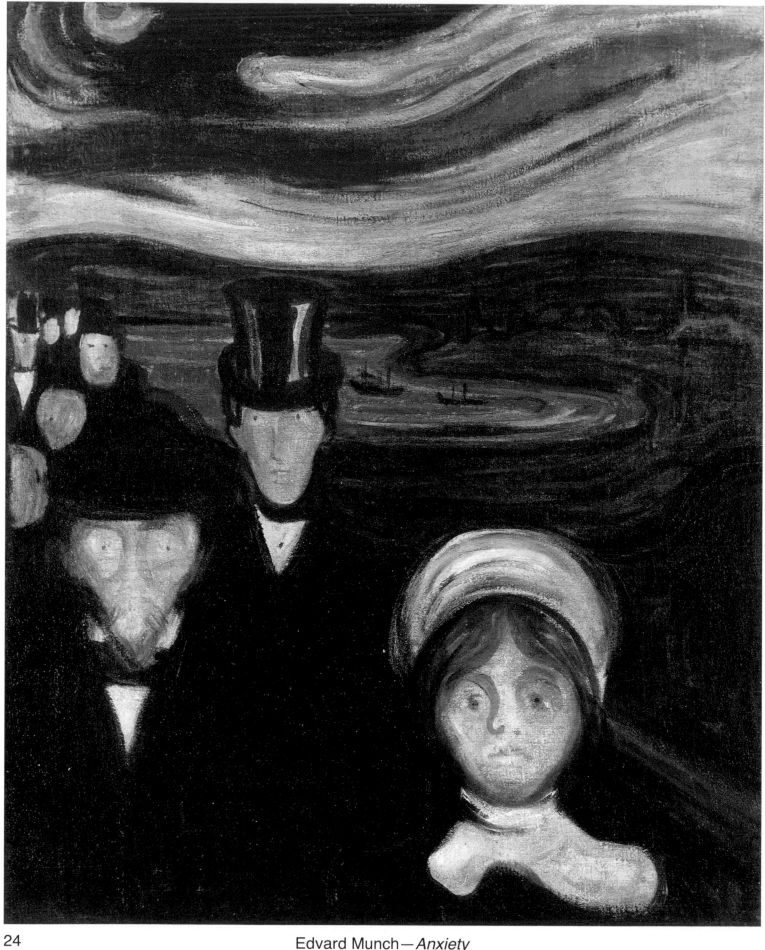

Edvard Munch—*Anxiety*

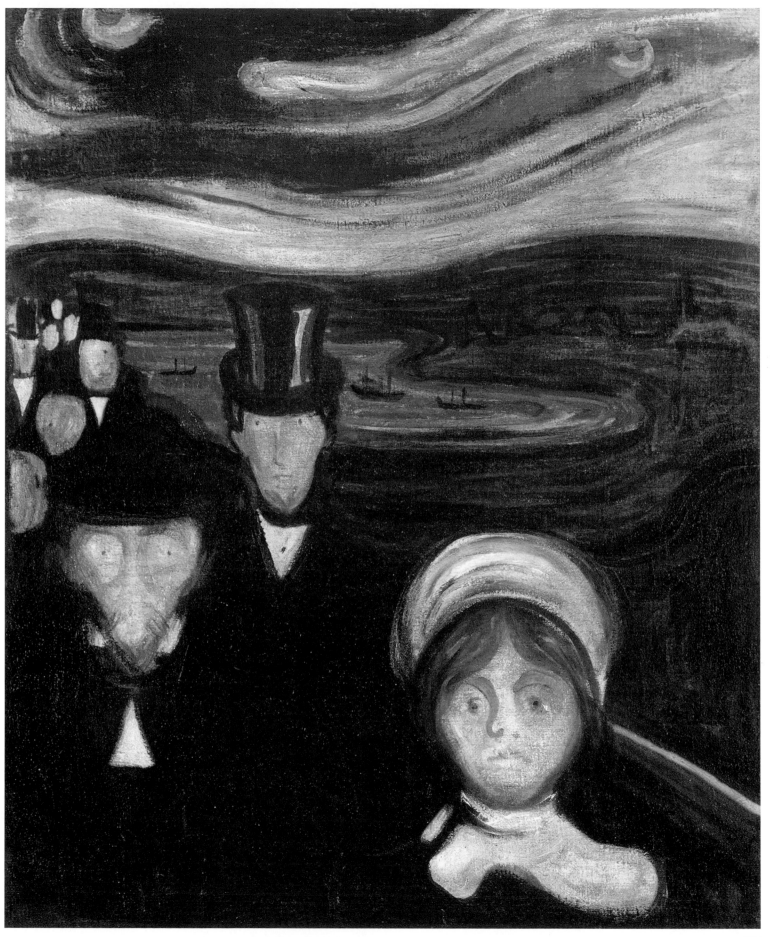

Number of differences: 12 Answers on page: 76

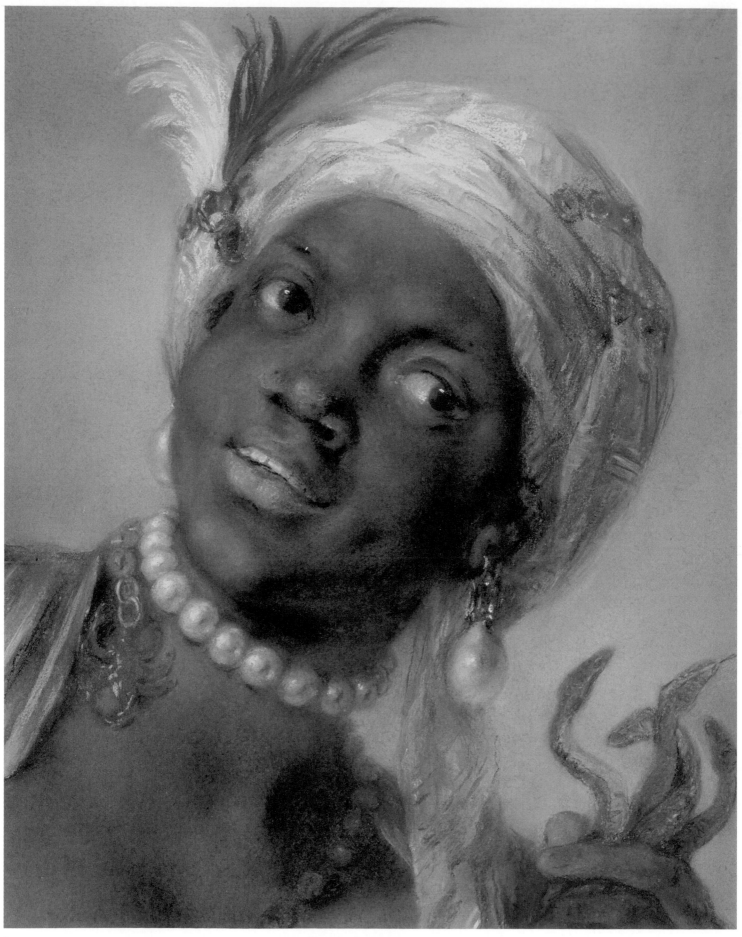

Rosalba Carriera—*Africa*

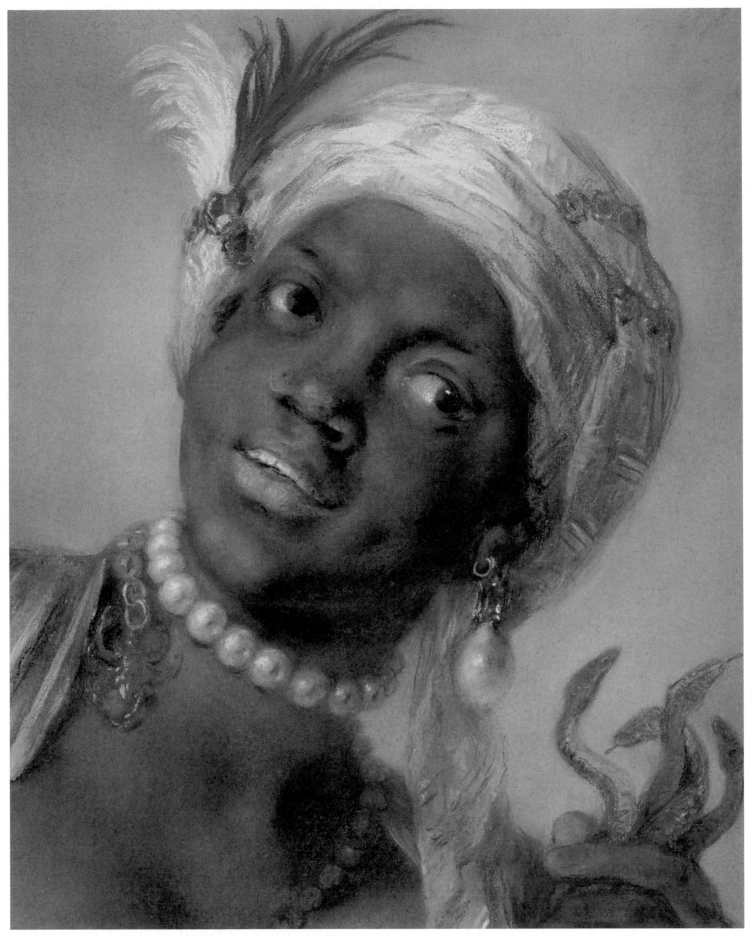

Number of differences: 10 Answers on page: 77 27

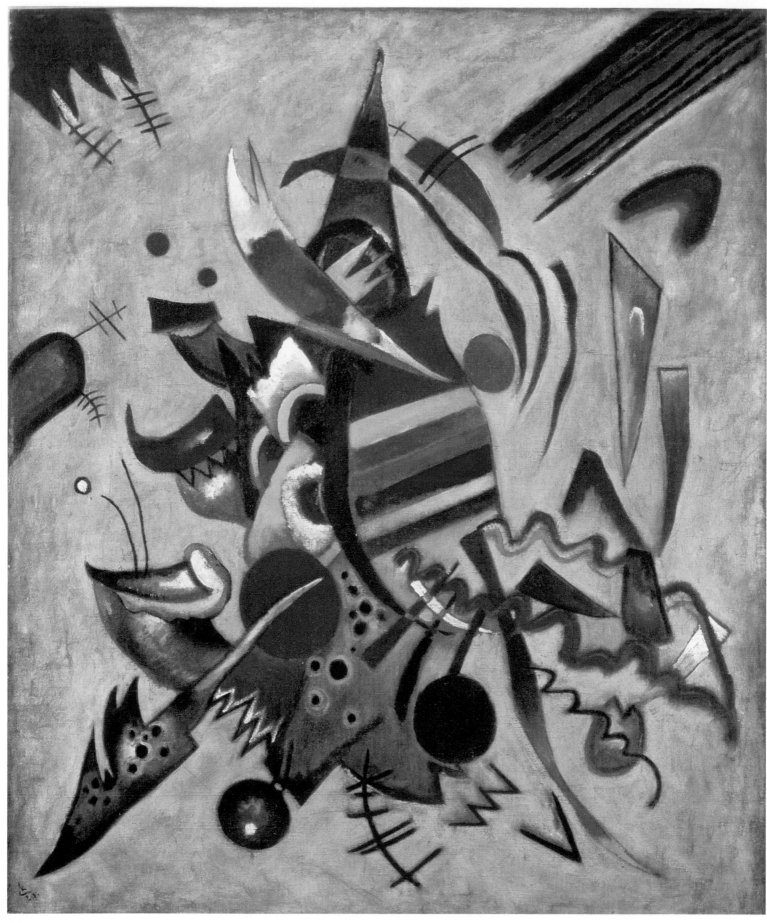

28 Wassily Kandinsky—*Points*

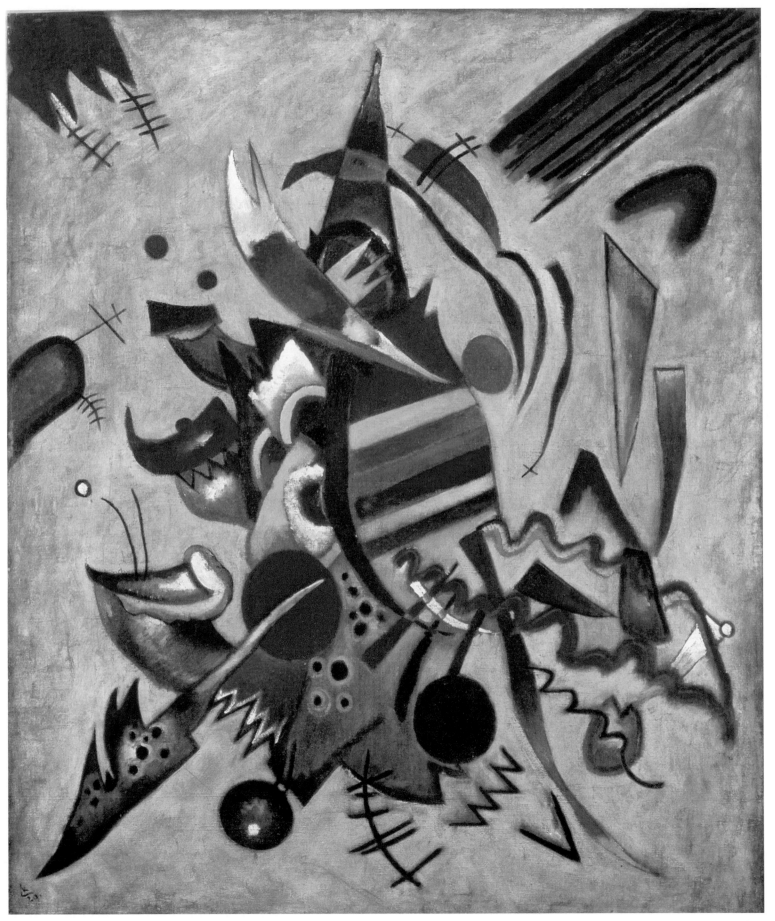

Number of differences: 17 Answers on page: 78 29

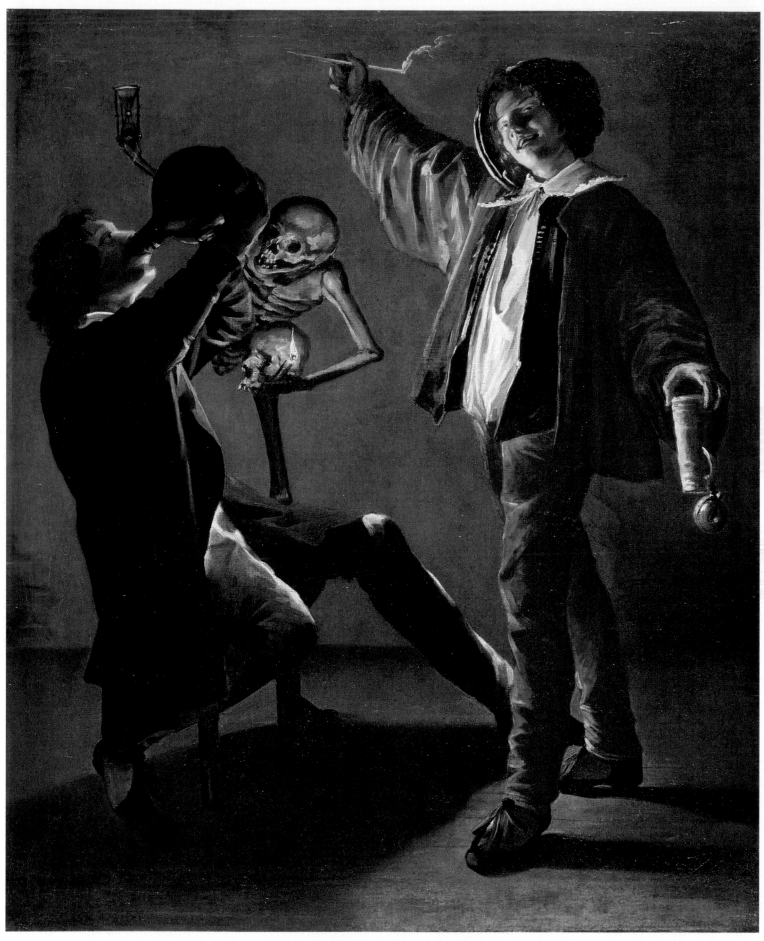

Judith Leyster— *The Last Drop*

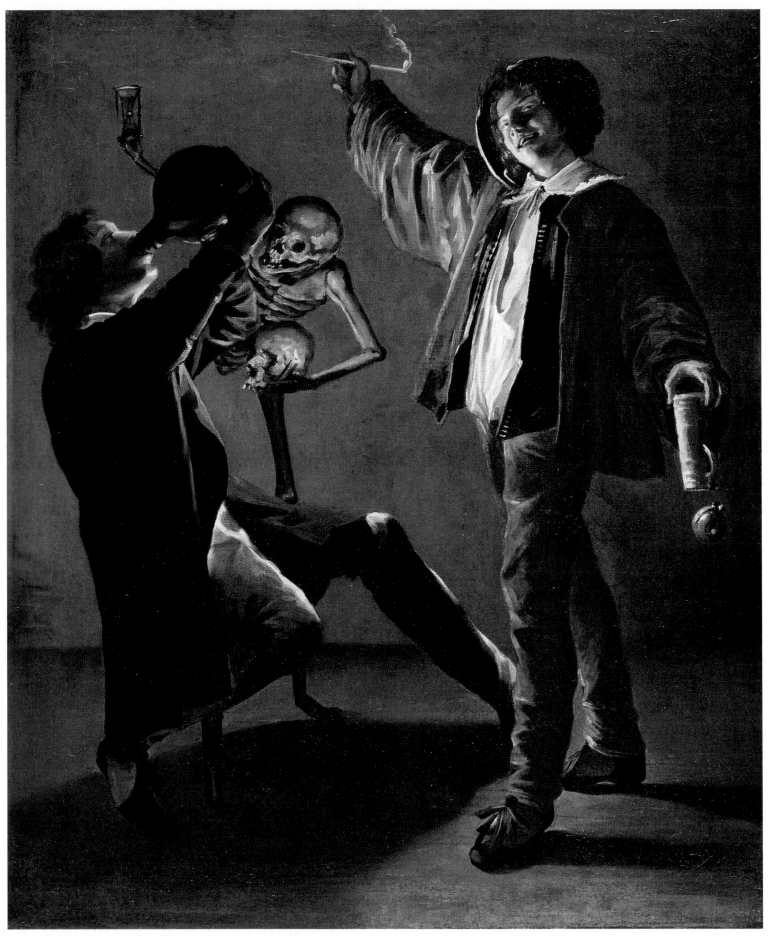

Number of differences: 13 Answers on page: 79

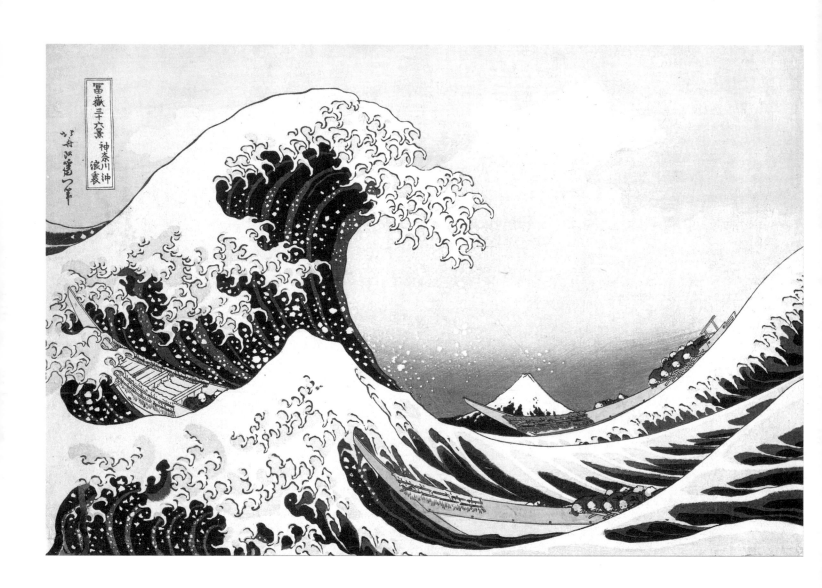

32 Katsushika Hokusai—*The Great Wave off Kanagawa*

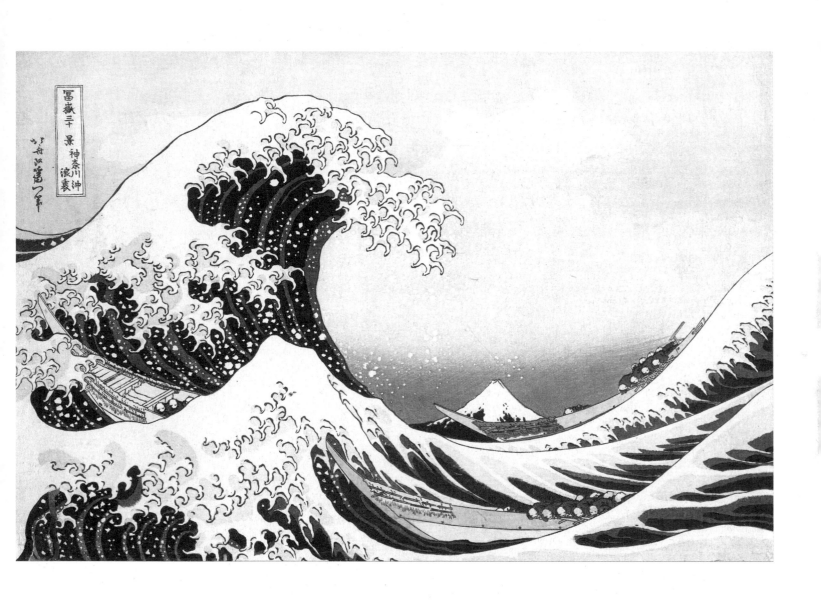

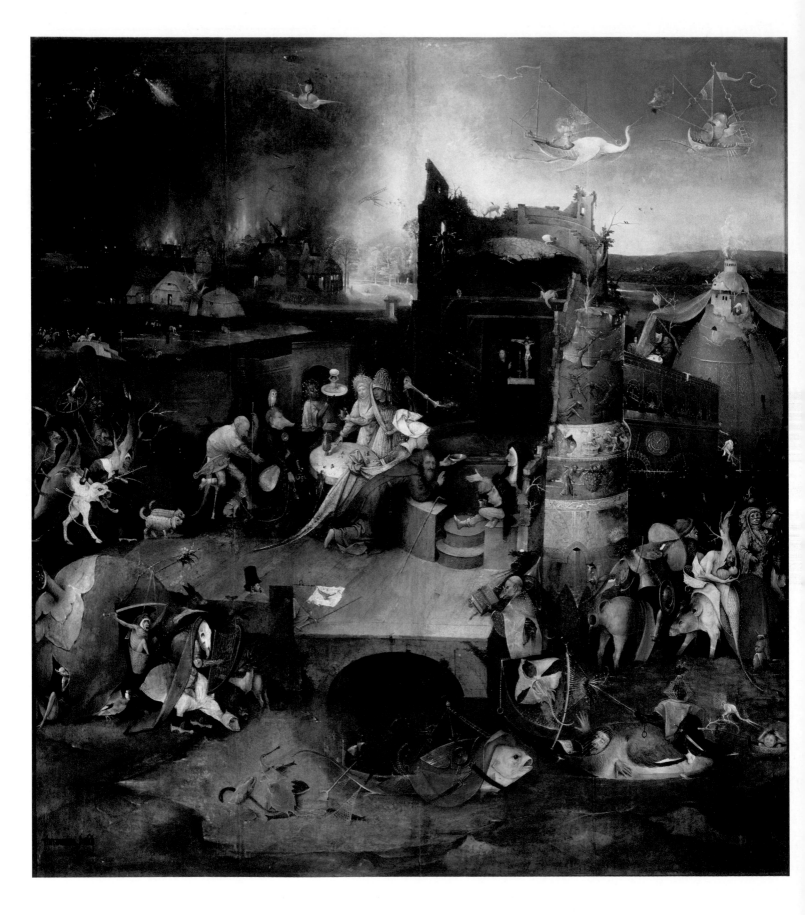

Hieronymus Bosch—*The Temptation of St. Anthony*

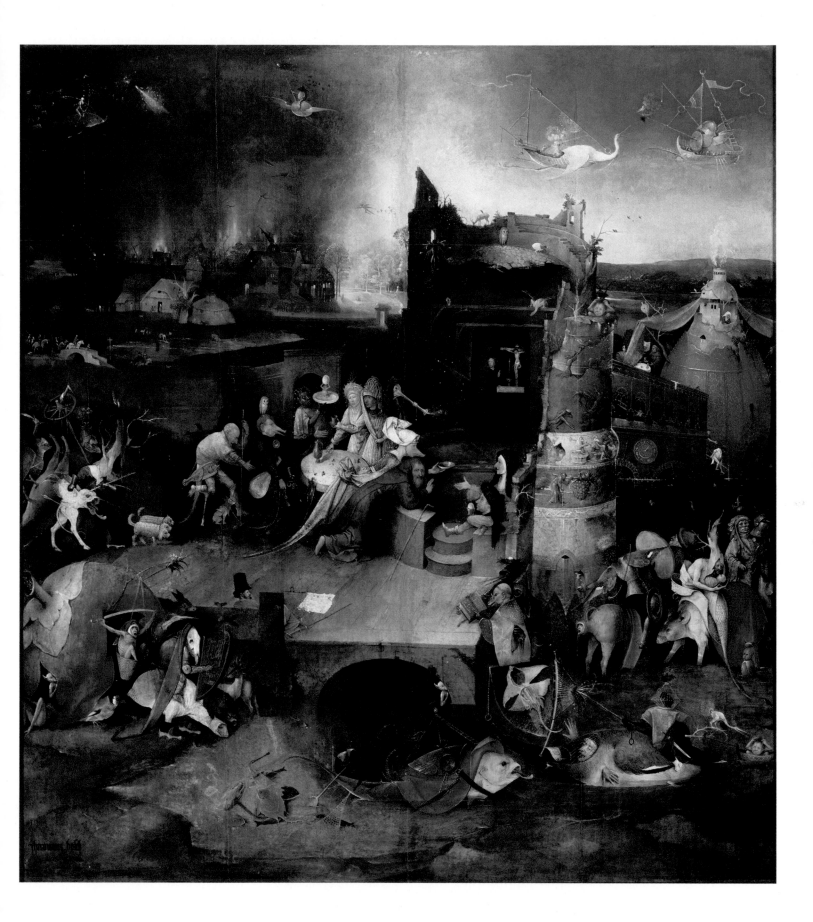

Number of differences: 18 Answers on page: 81 35

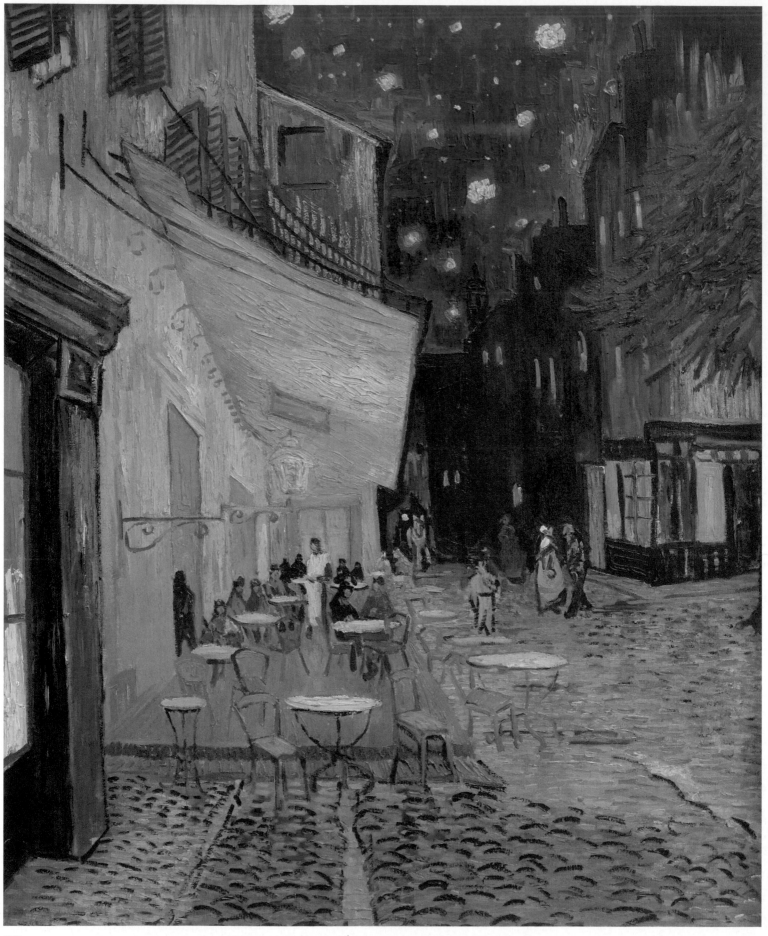

Vincent van Gogh—*Café Terrace at Night*

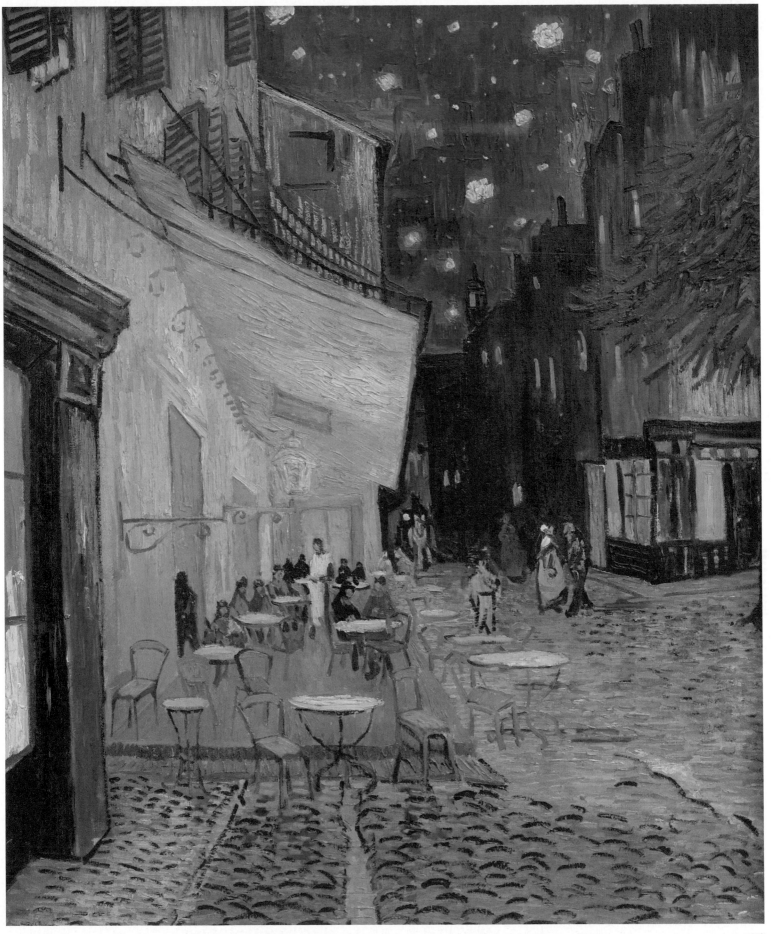

Number of differences: 12 Answers on page: 82 37

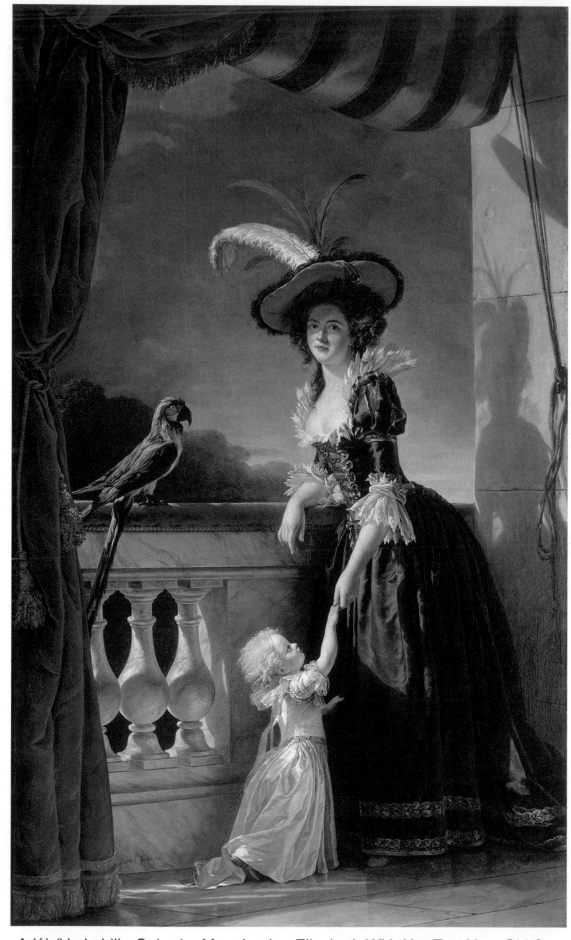

Adélaïde Labille-Guiard—*Mme Louise-Elisabeth With Her Two Year Old Son*

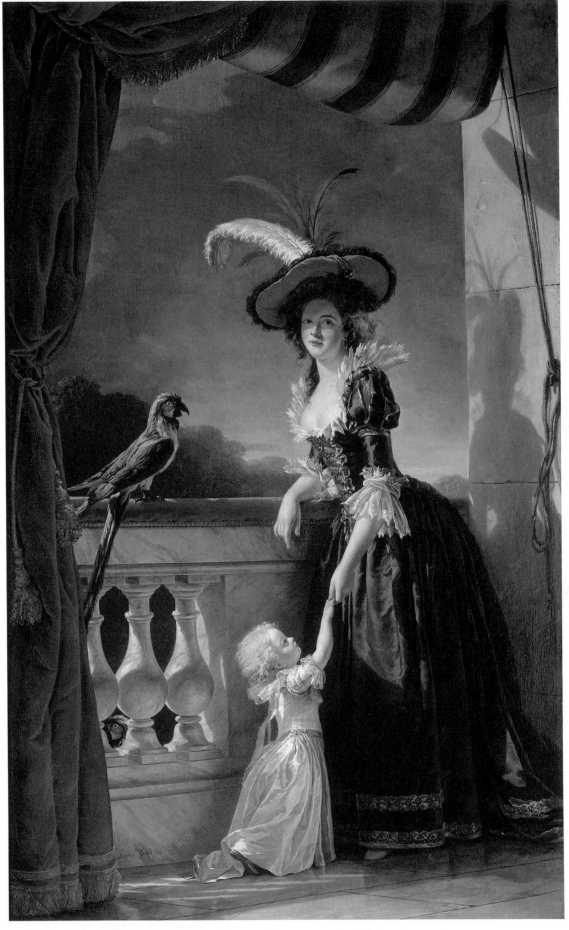

Number of differences: 11 Answers on page: 83 39

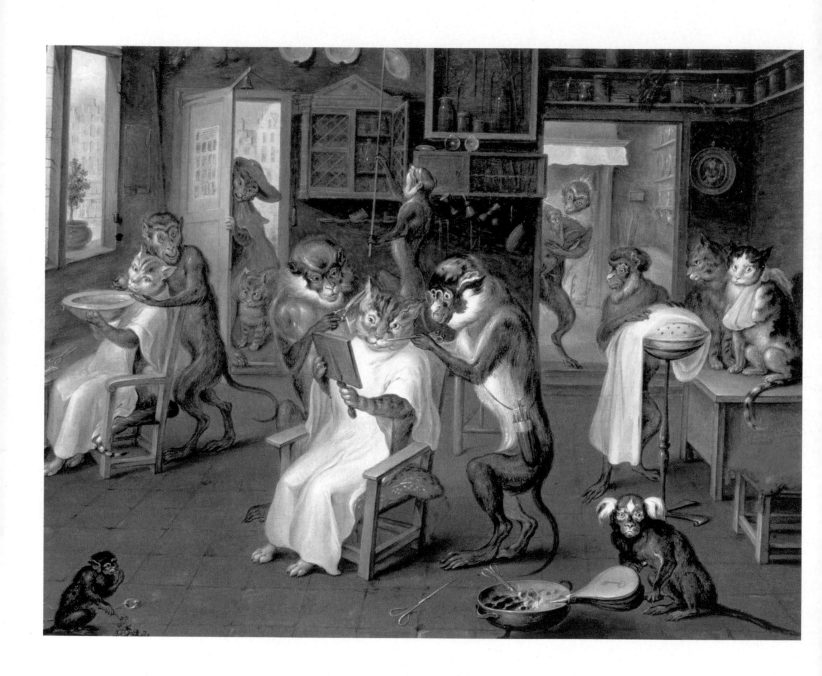

40 Abraham Teniers—*Barbershop with Monkeys and Cats*

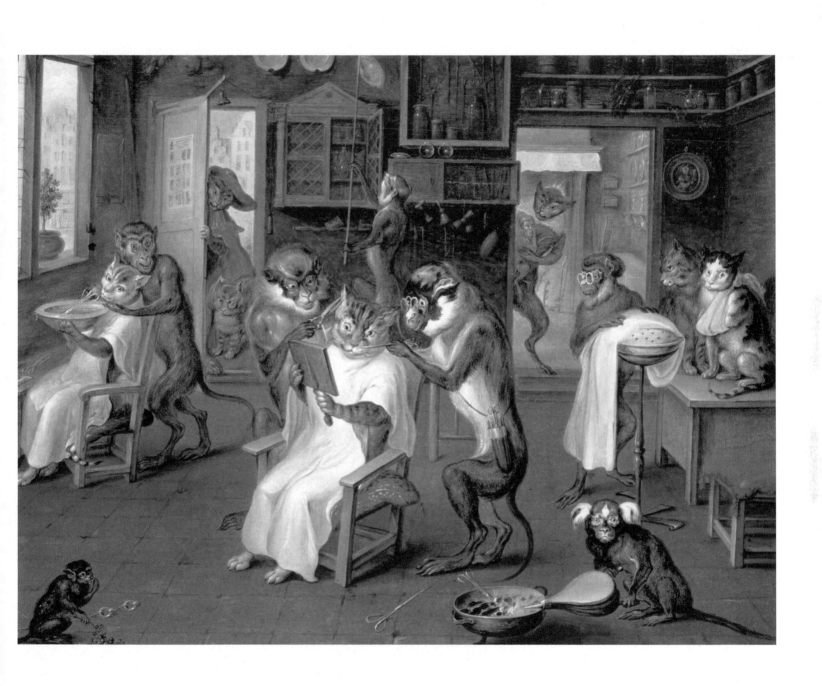

Number of differences: 18 Answers on page: 84 41

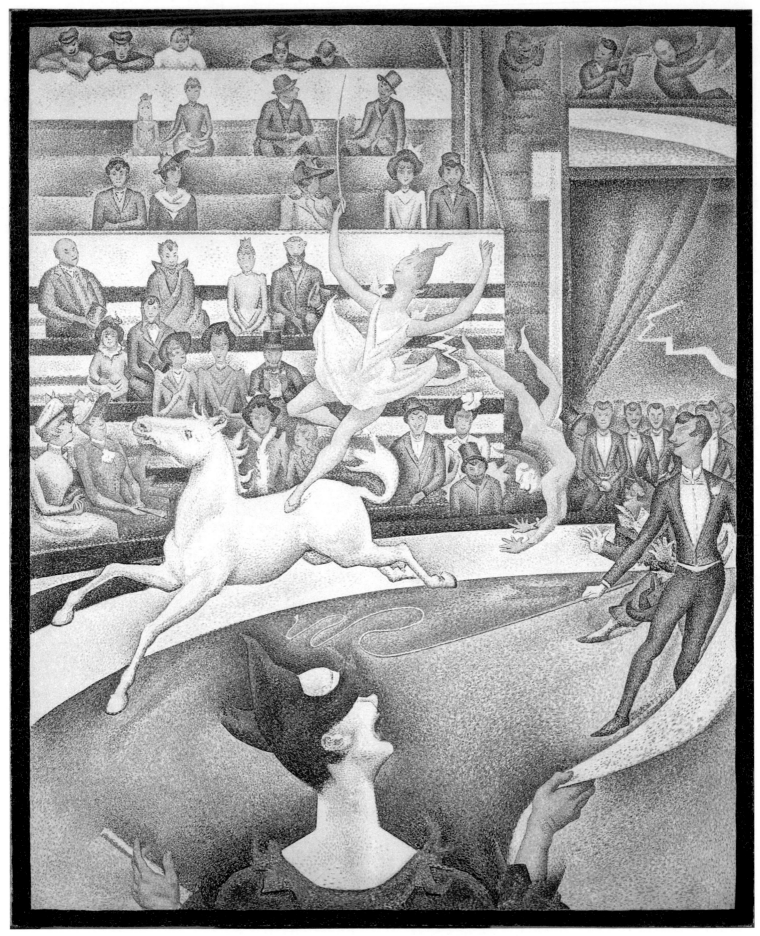

Georges Seurat—*The Circus*

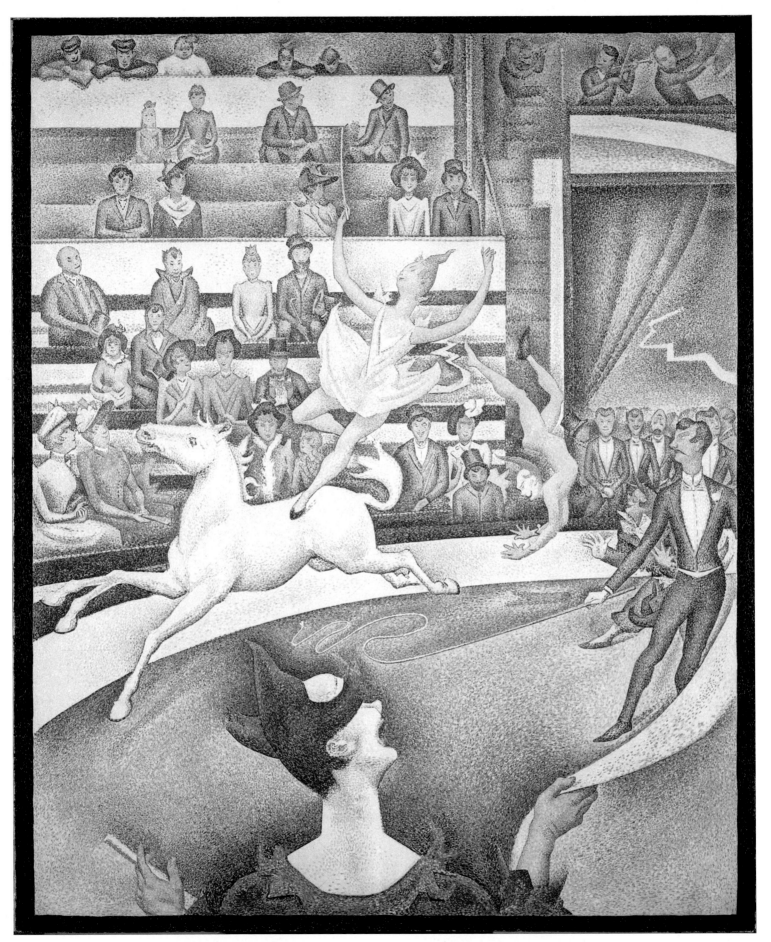

Number of differences: 14 Answers on page: 85 43

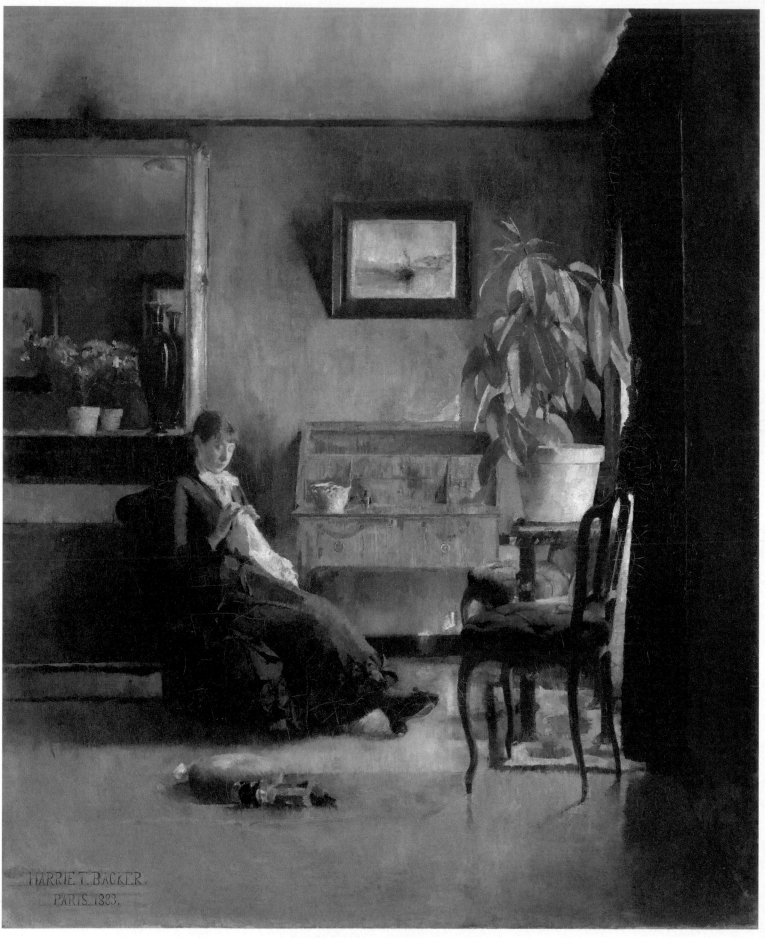

Harriet Backer—*Blue Interior*

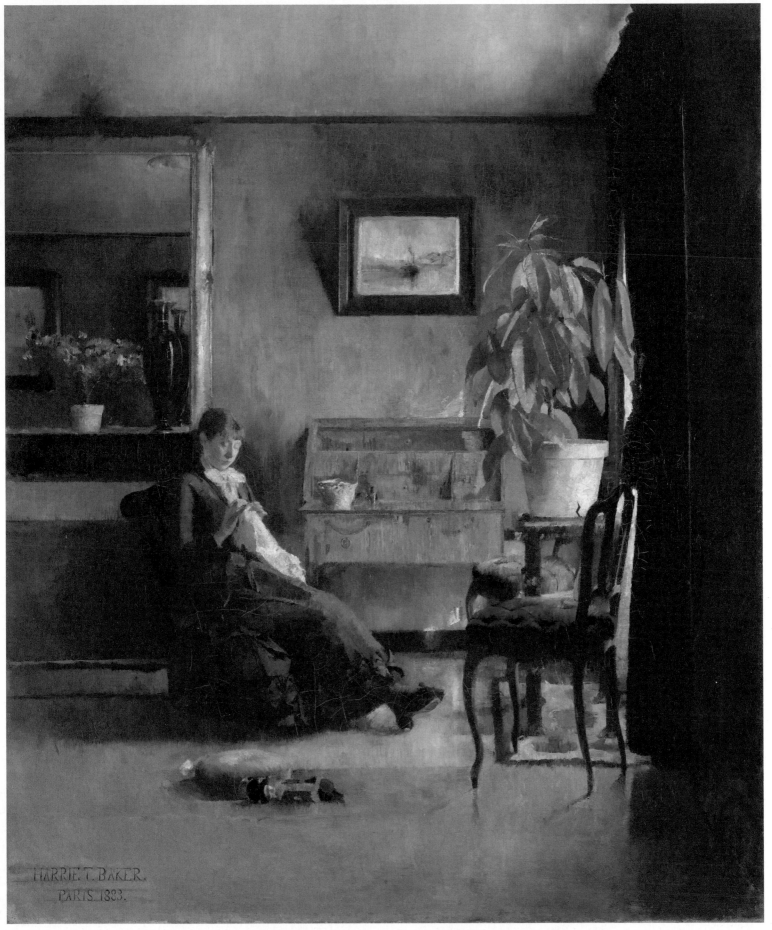

Number of differences: 11 Answers on page: 86 45

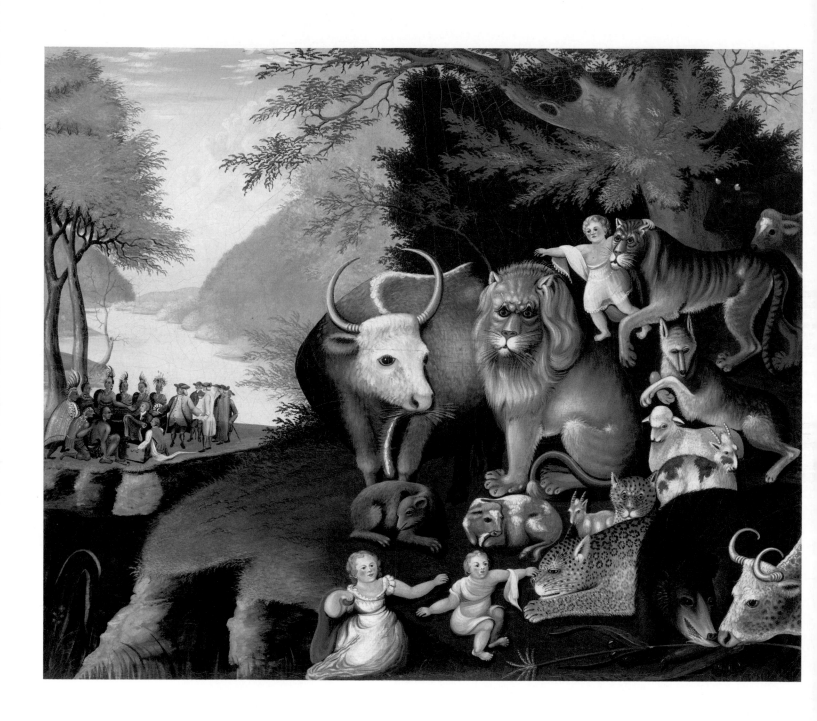

46 Edward Hicks—*Peaceable Kingdom*

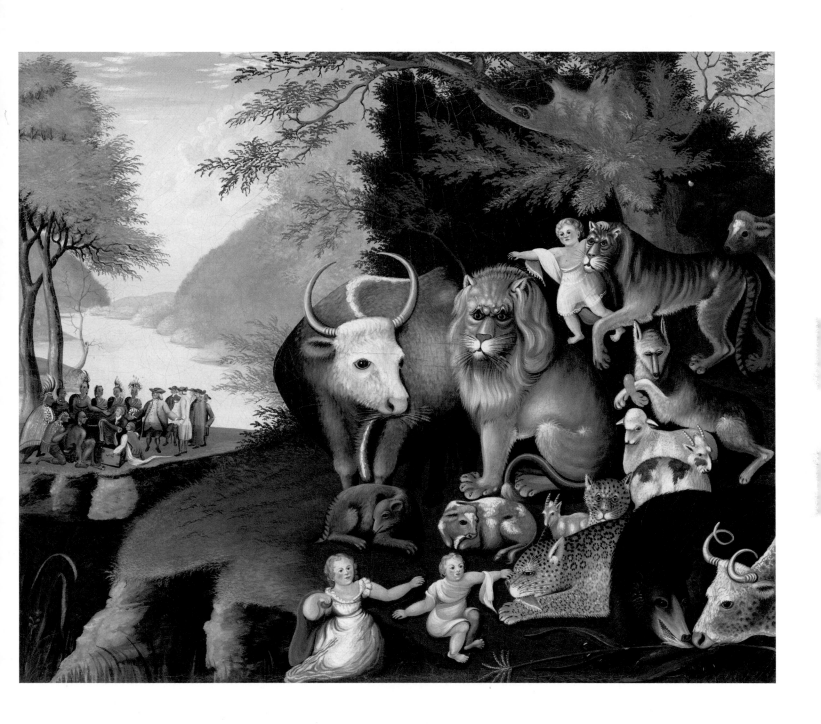

Number of differences: 15 Answers on page: 87 47

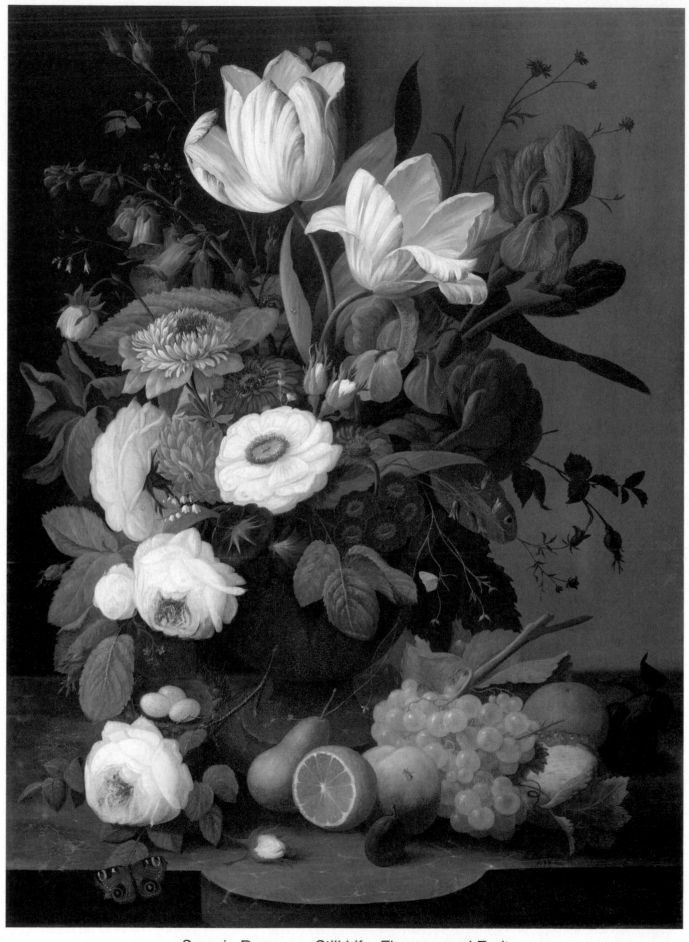

Severin Roesen—*Still Life, Flowers, and Fruit*

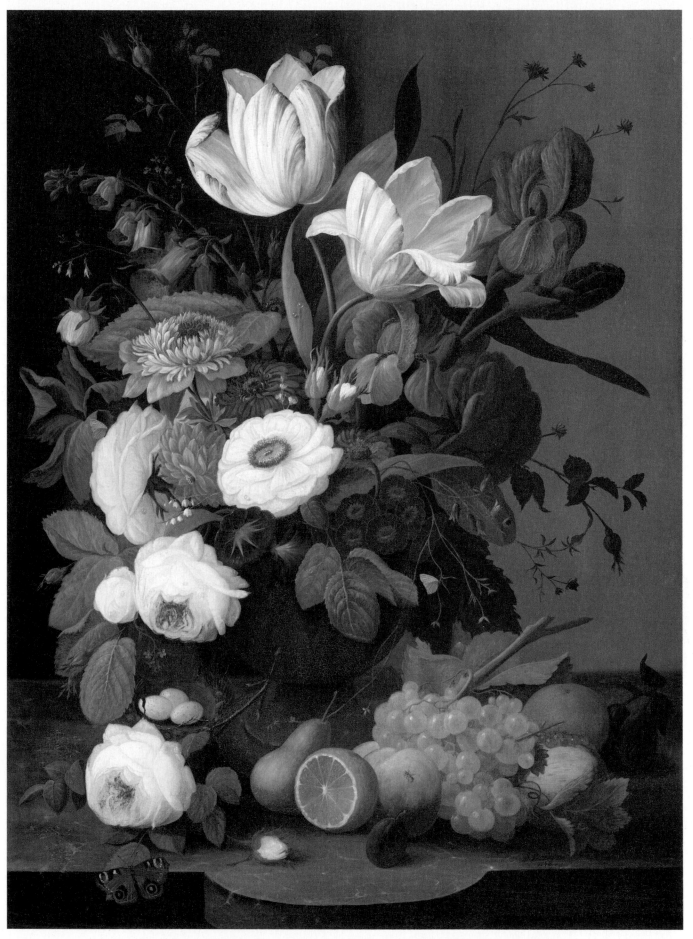

Number of differences: 18 Answers on page: 88 49

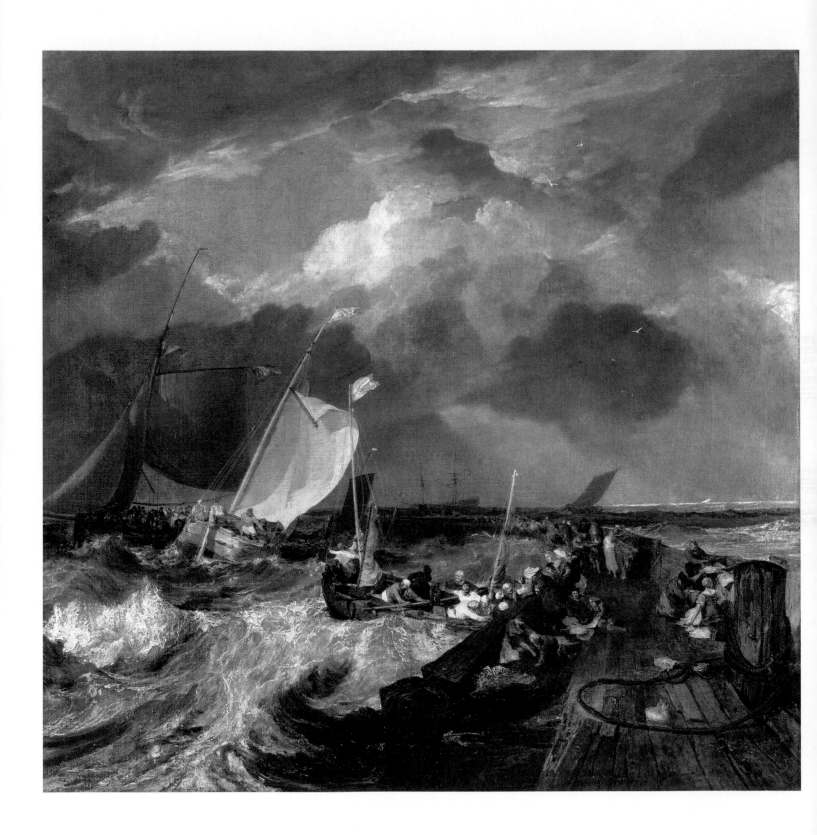

Joseph Mallord William Turner—*Calais Pier*

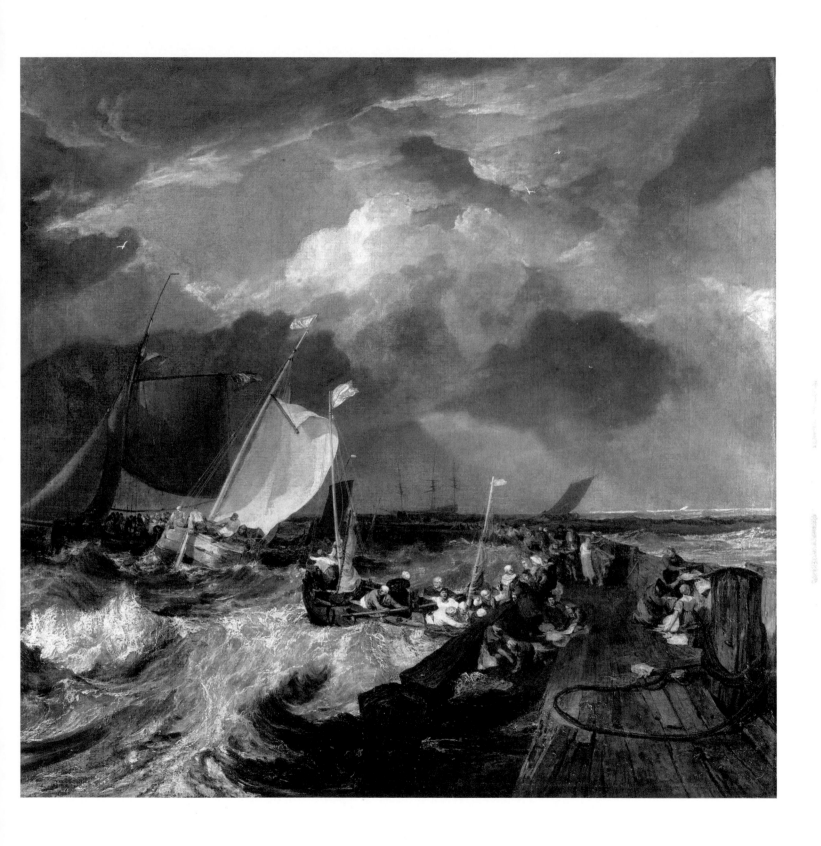

Number of differences: 13 Answers on page: 89

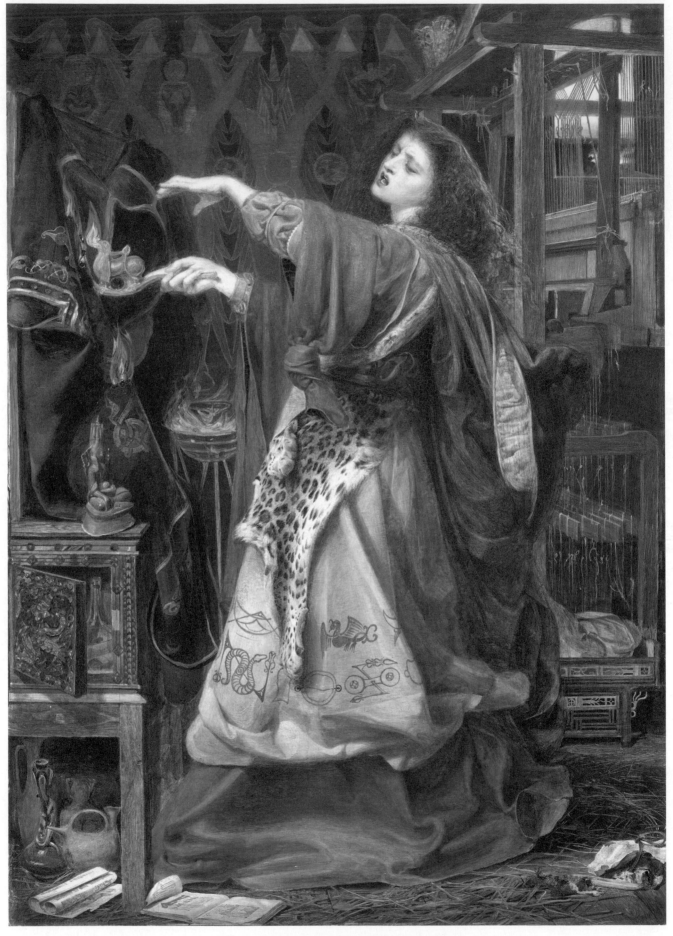

Frederick Sandys—*Morgan le Fay*

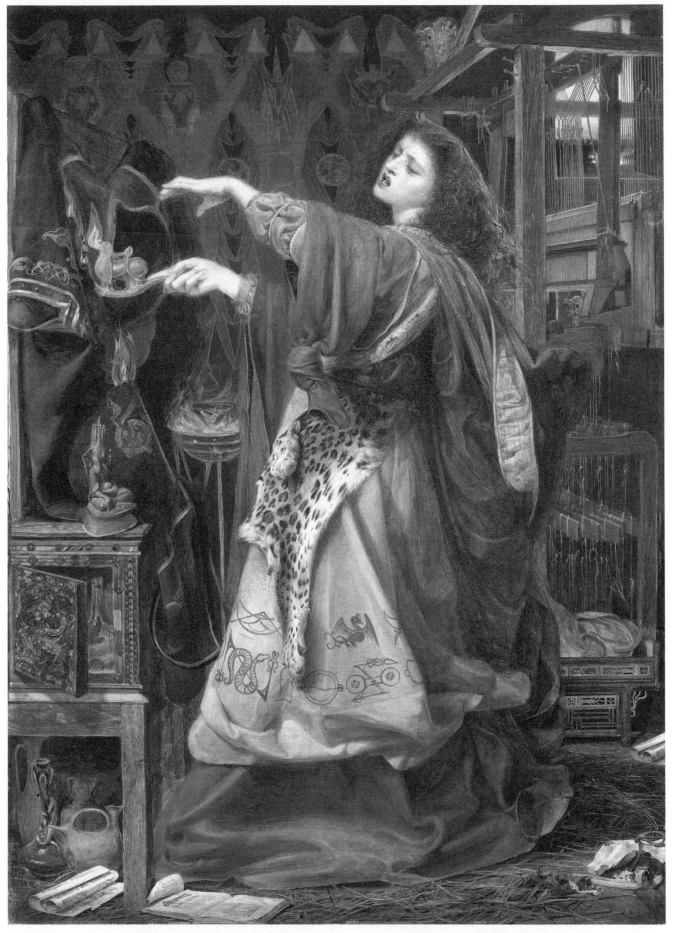

Number of differences: 13 Answers on page: 90 53

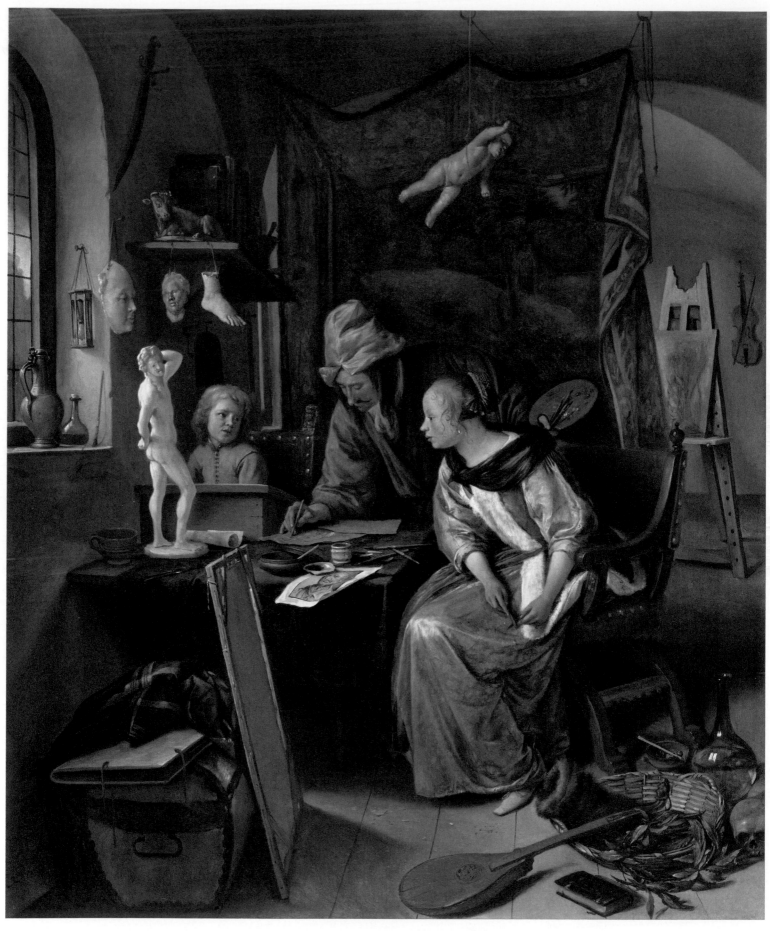

Jan Steen—*The Drawing Lesson*

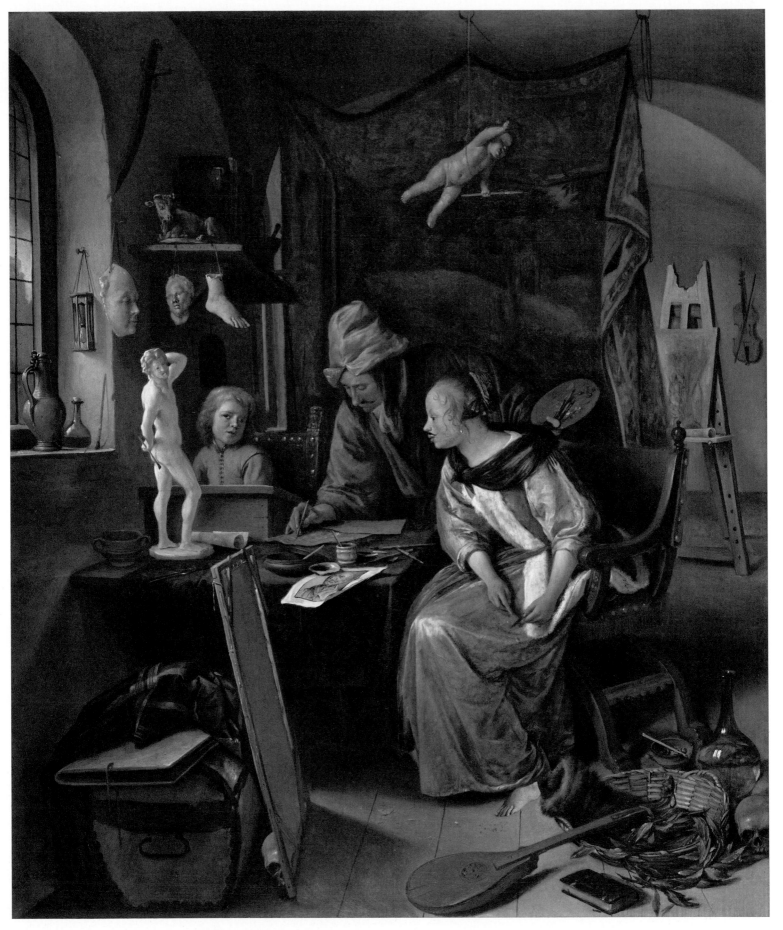

Number of differences: 17 Answers on page: 91 55

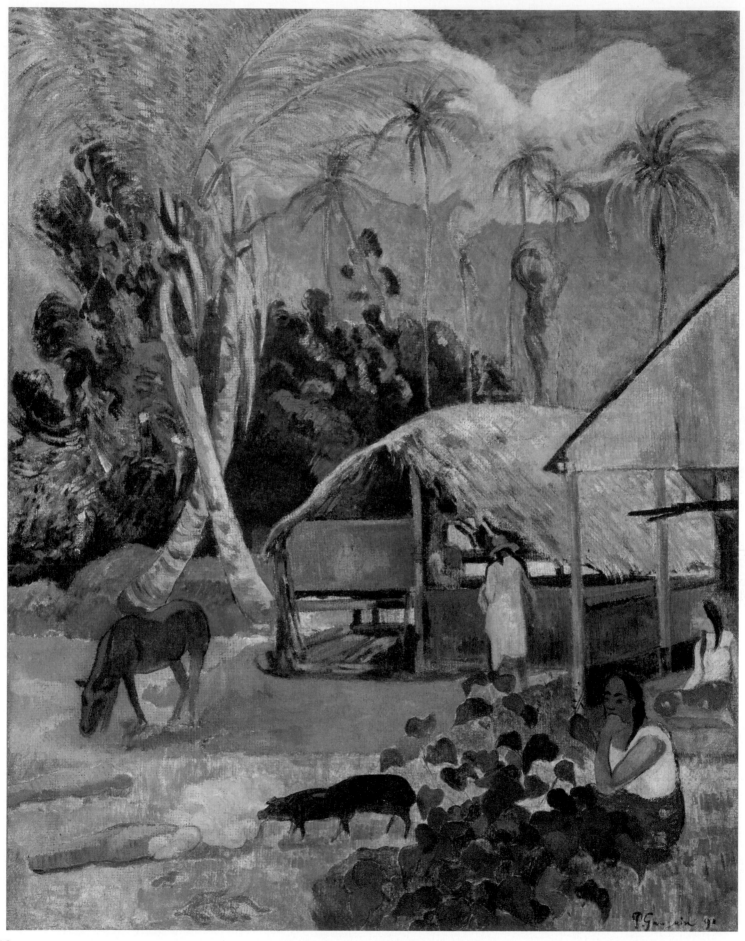

56 Paul Gauguin—*The Black Pigs*

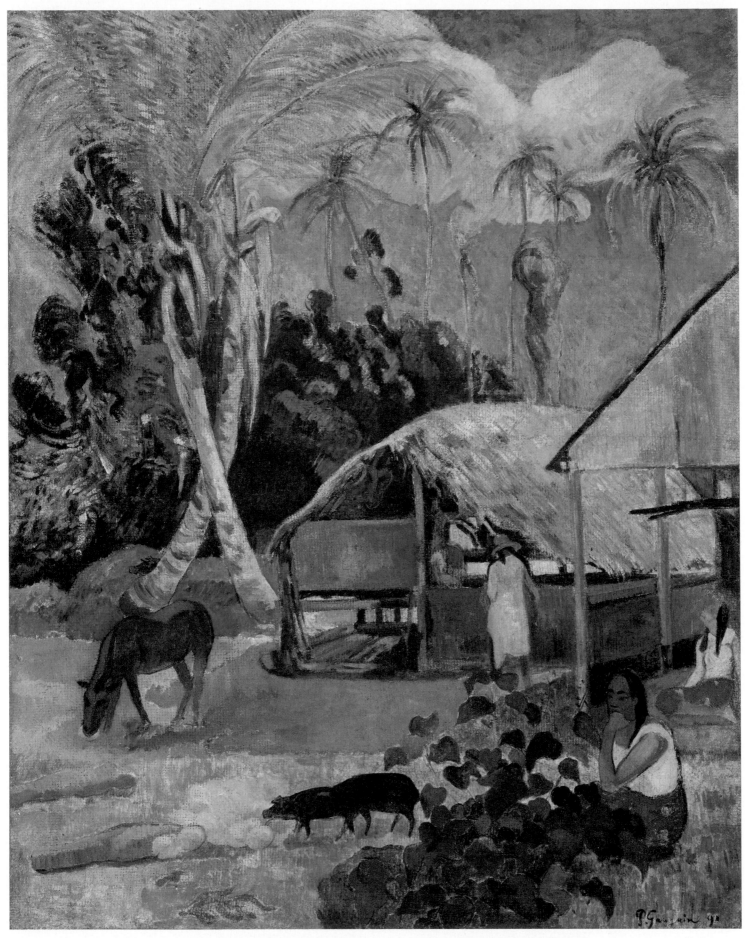

Number of differences: 14 Answers on page: 92 57

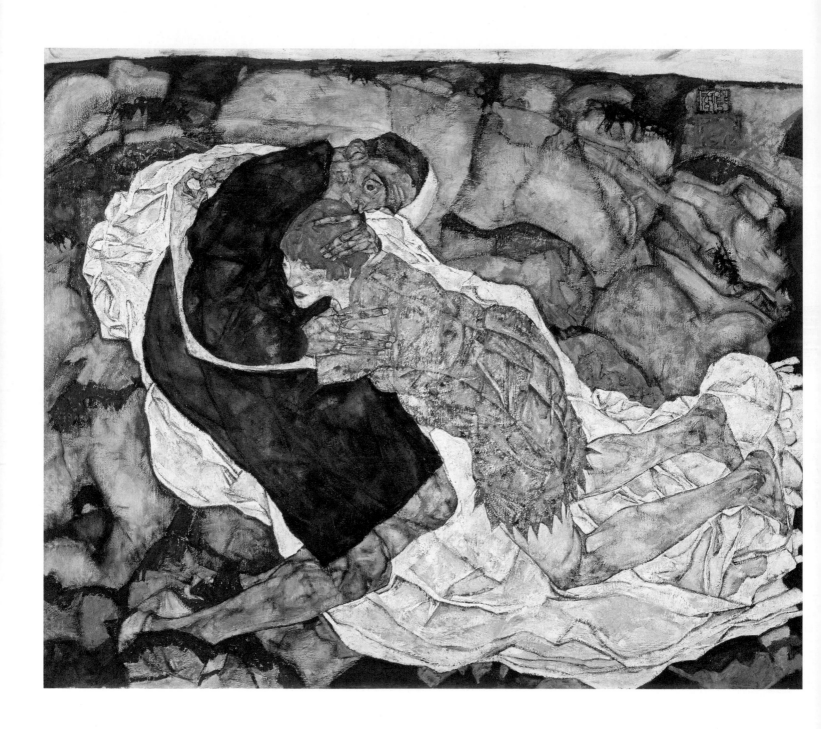

　　　　　　　　　　　Egon Schiele—*Death and the Maiden*

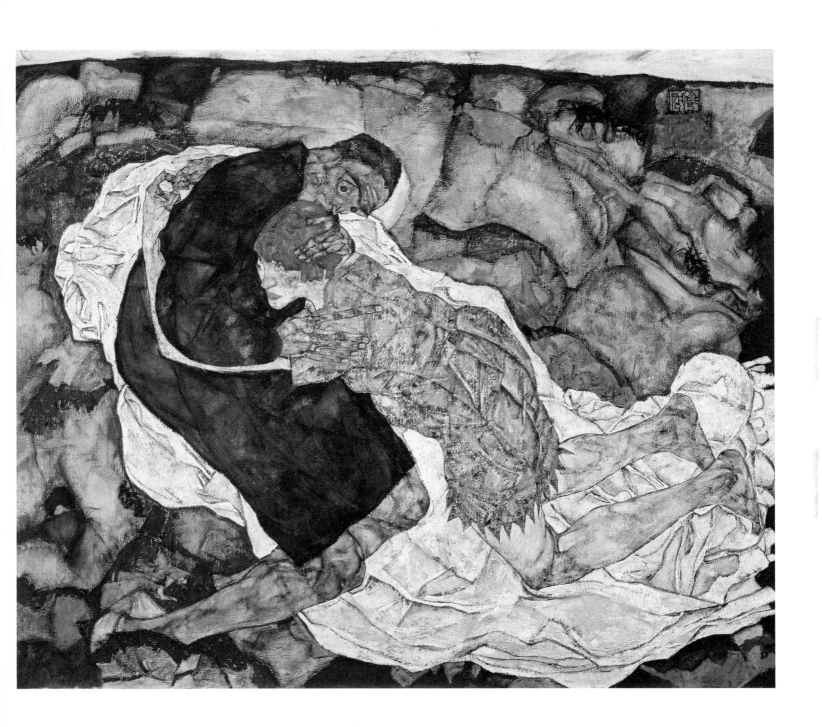

Number of differences: 10 Answers on page: 93 59

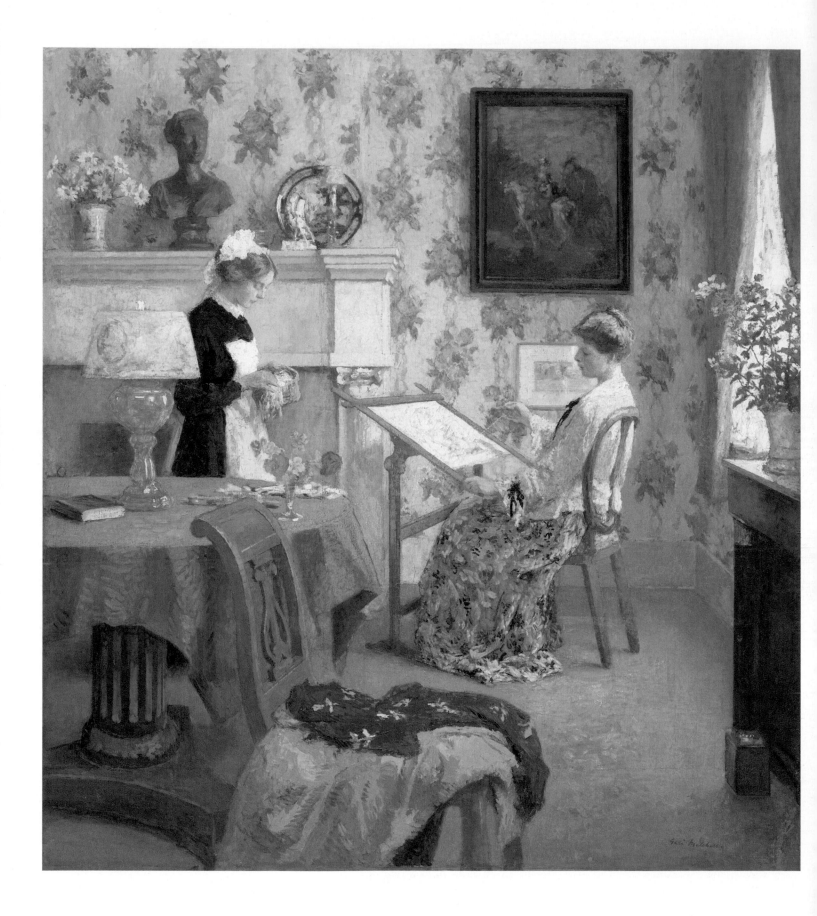

Gari Melchers—*Penelope*

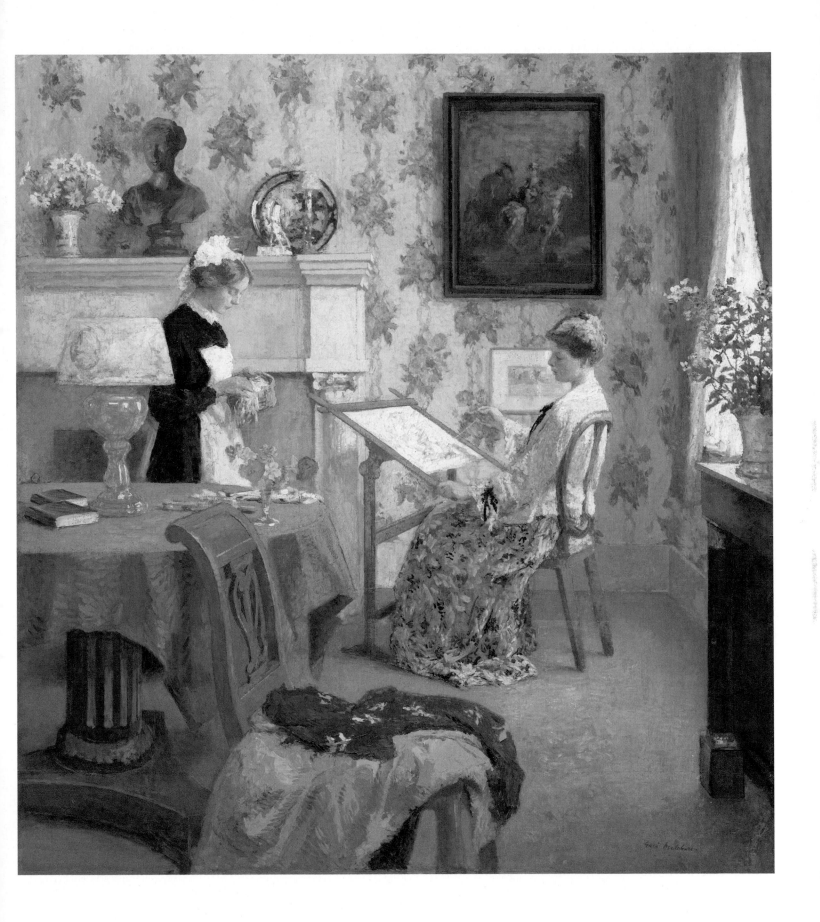

Number of differences: 12 Answers on page: 94 61

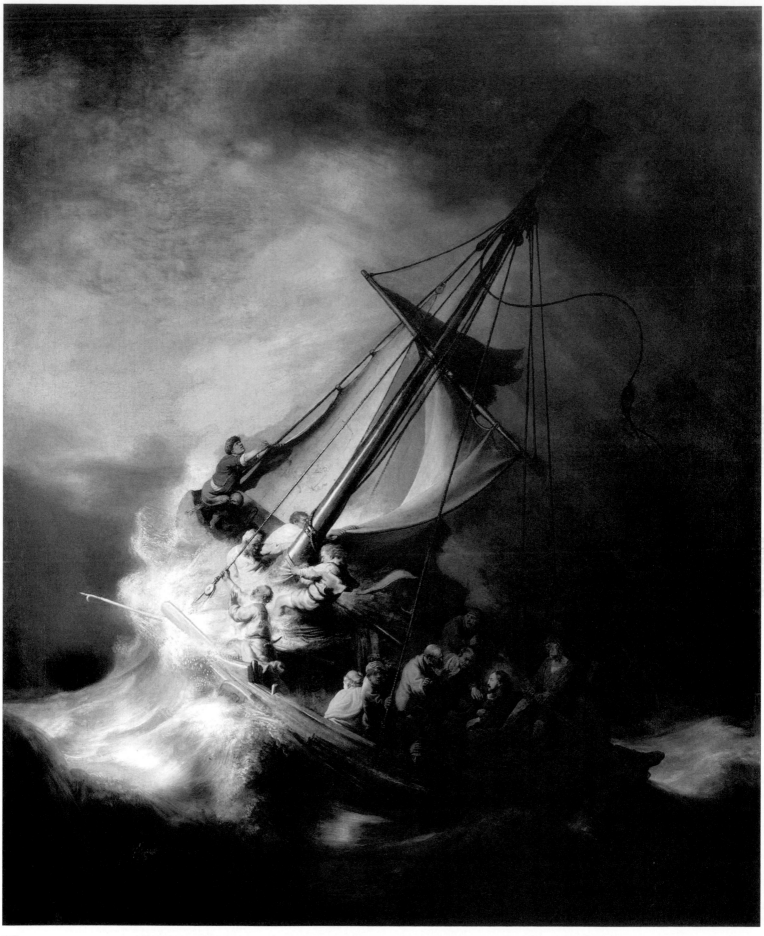

Rembrandt Harmenszoon van Rijn — *The Storm on the Sea of Galilee*

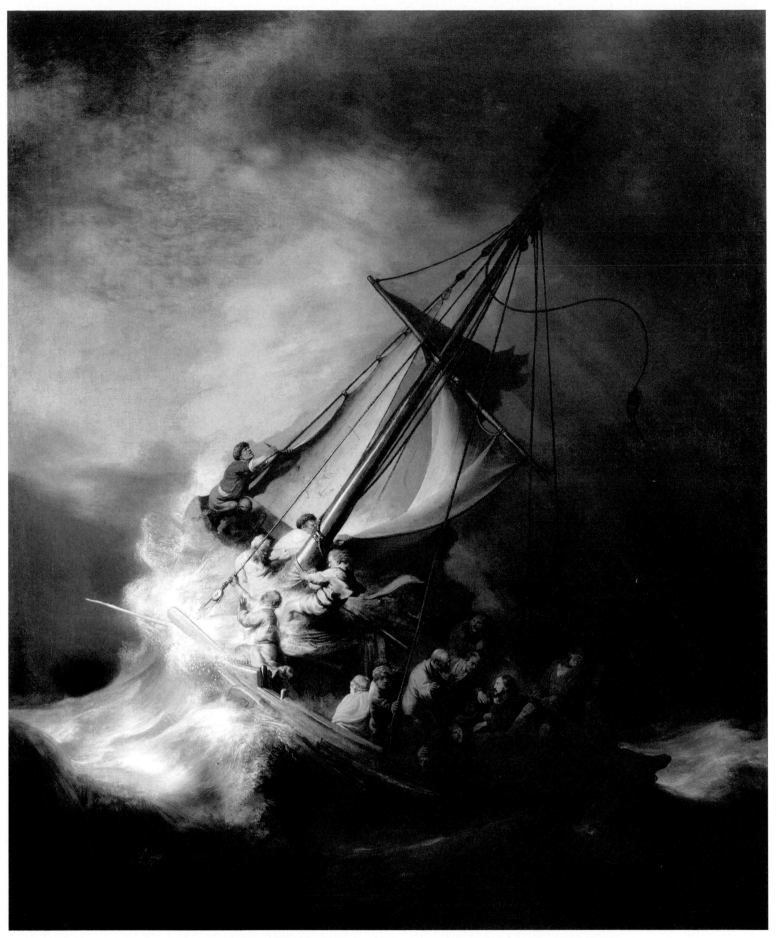

Number of differences: 16 Answers on page: 95

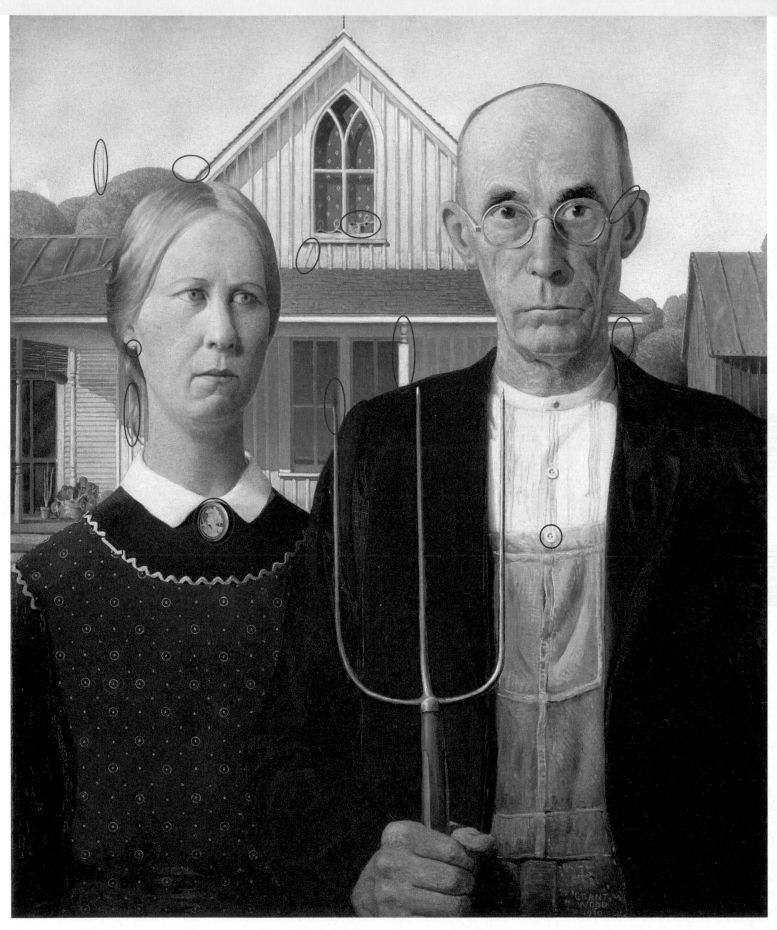

Grant Wood — *American Gothic*

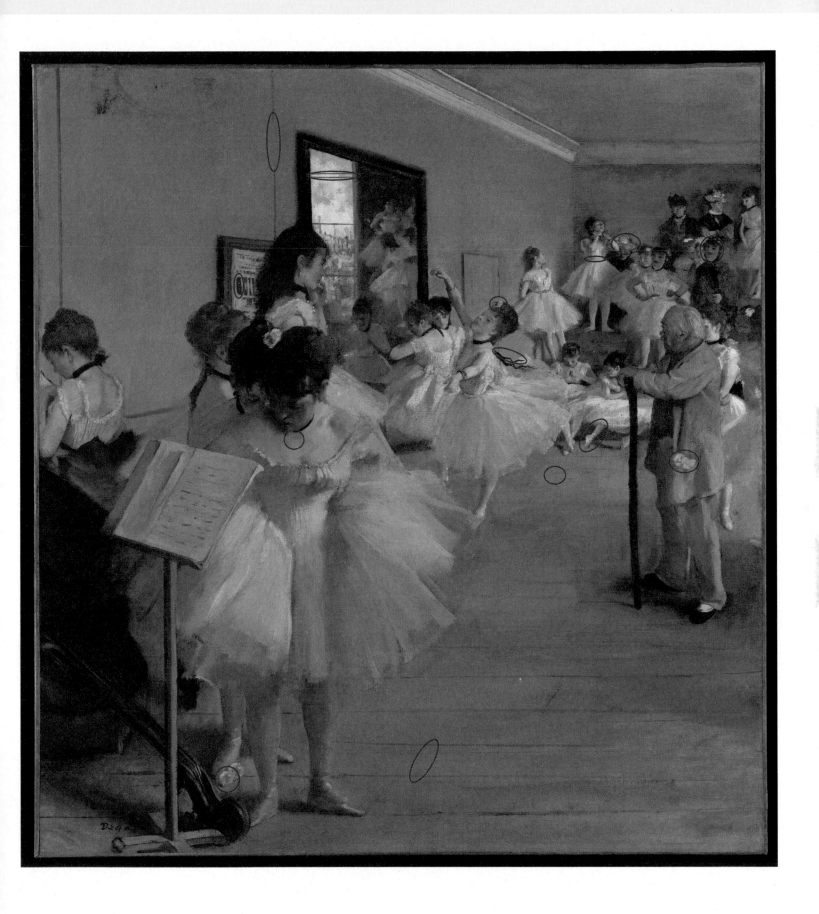

Edgar Degas—*The Ballet Class*

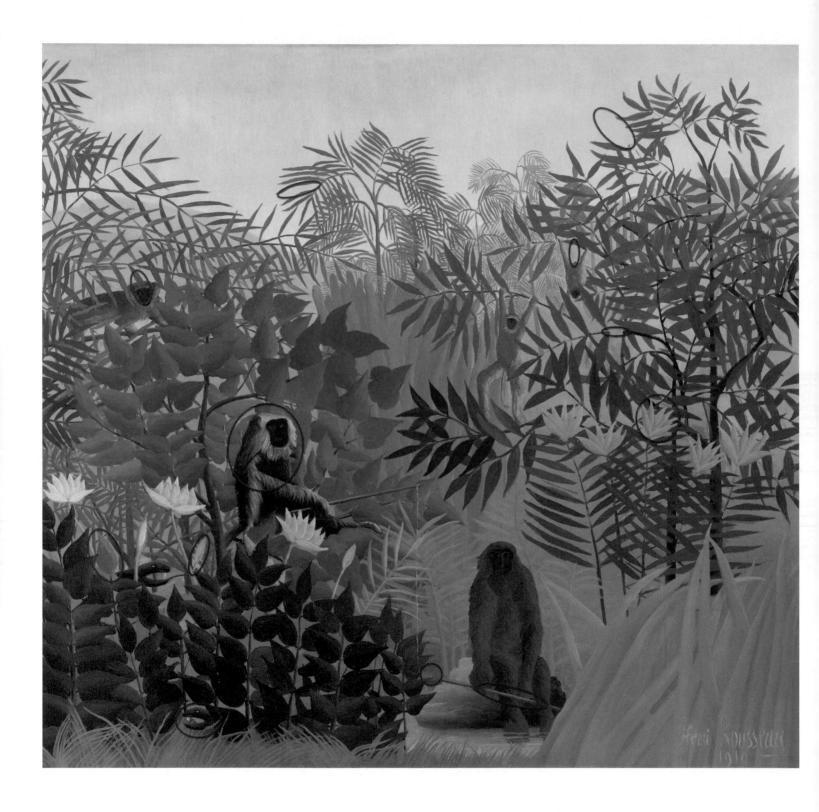

Henri Rousseau — *Tropical Forest with Monkeys*

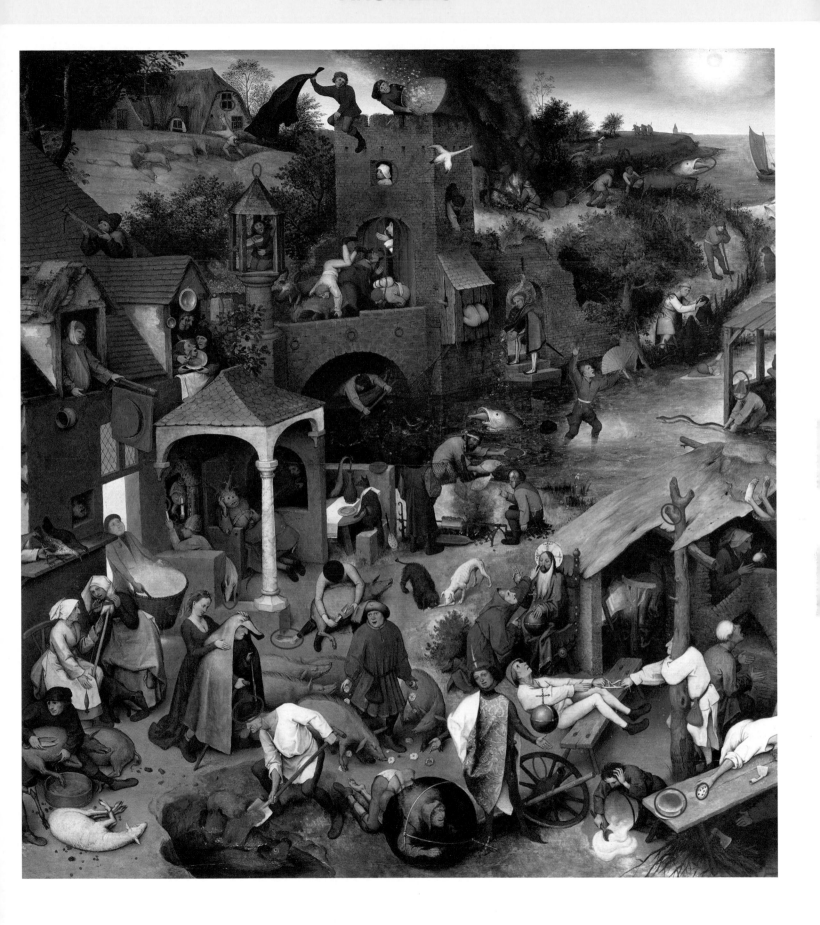

Pieter Brueghel the Elder — *The Dutch Proverbs*

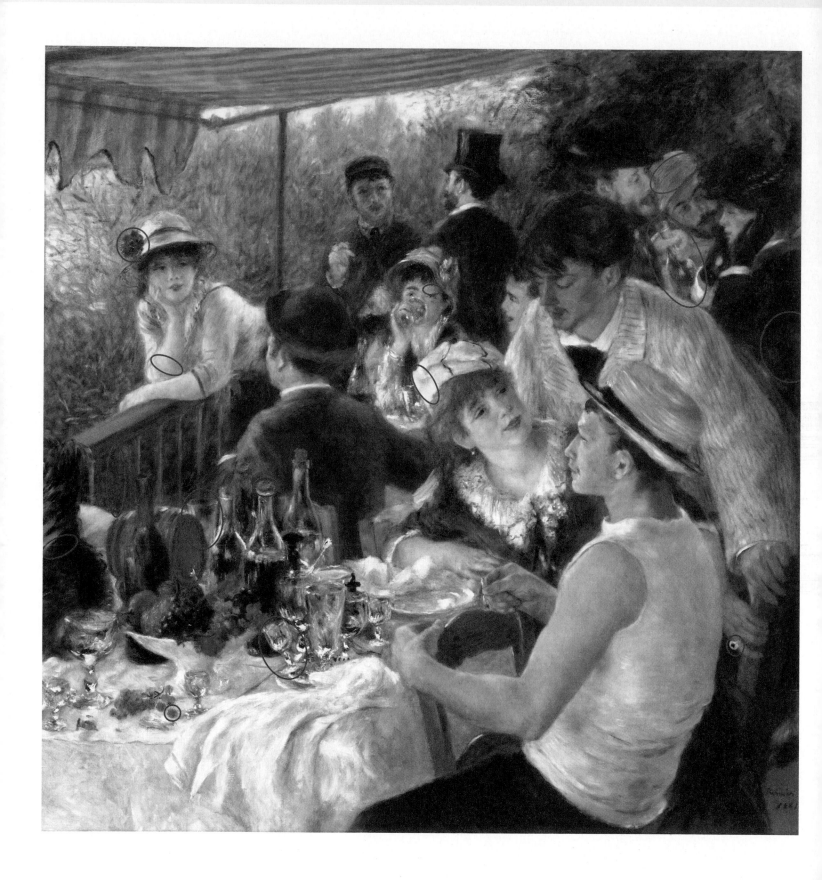

Pierre-Auguste Renoir — *Luncheon of the Boating Party*

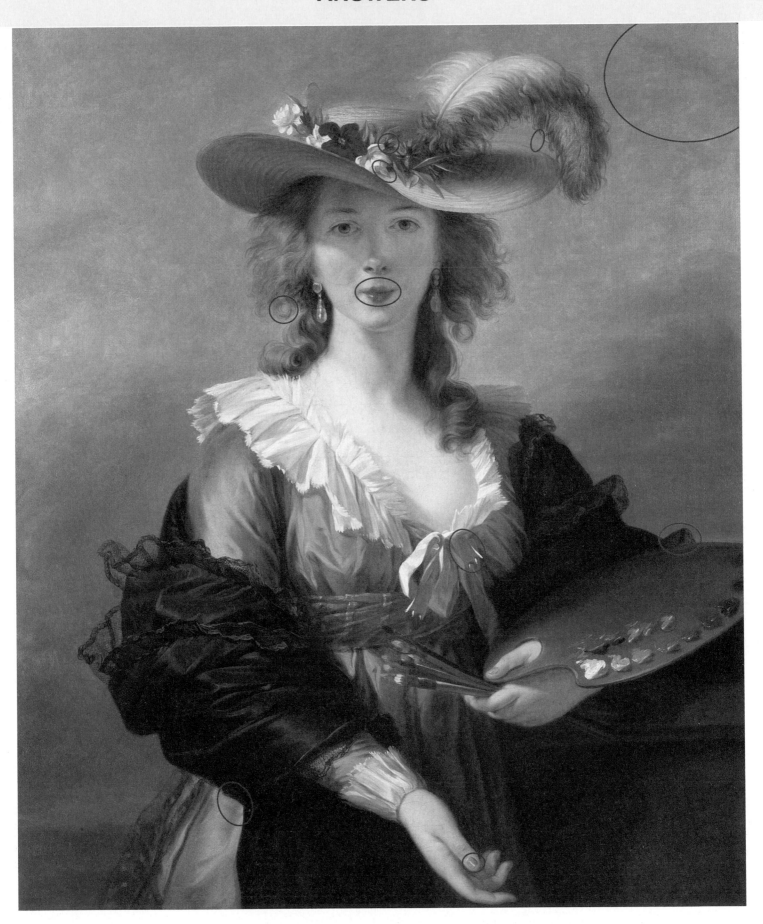

Élisabeth Vigée Le Brun—*Self-portrait in a Straw Hat*

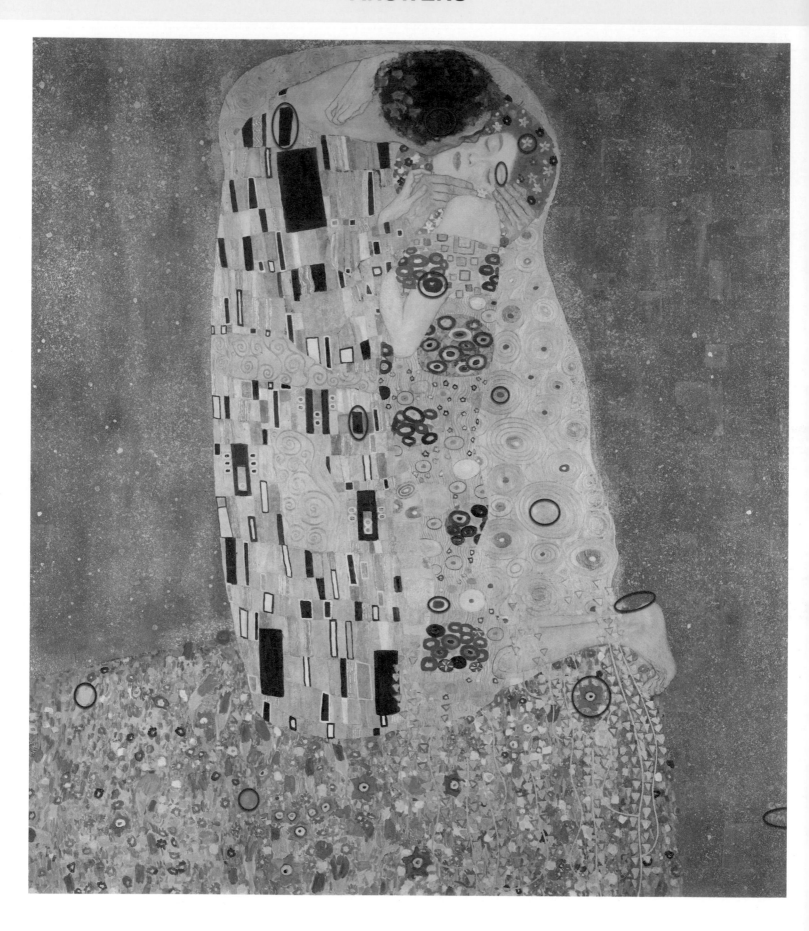

Gustav Klimt — *The Kiss*

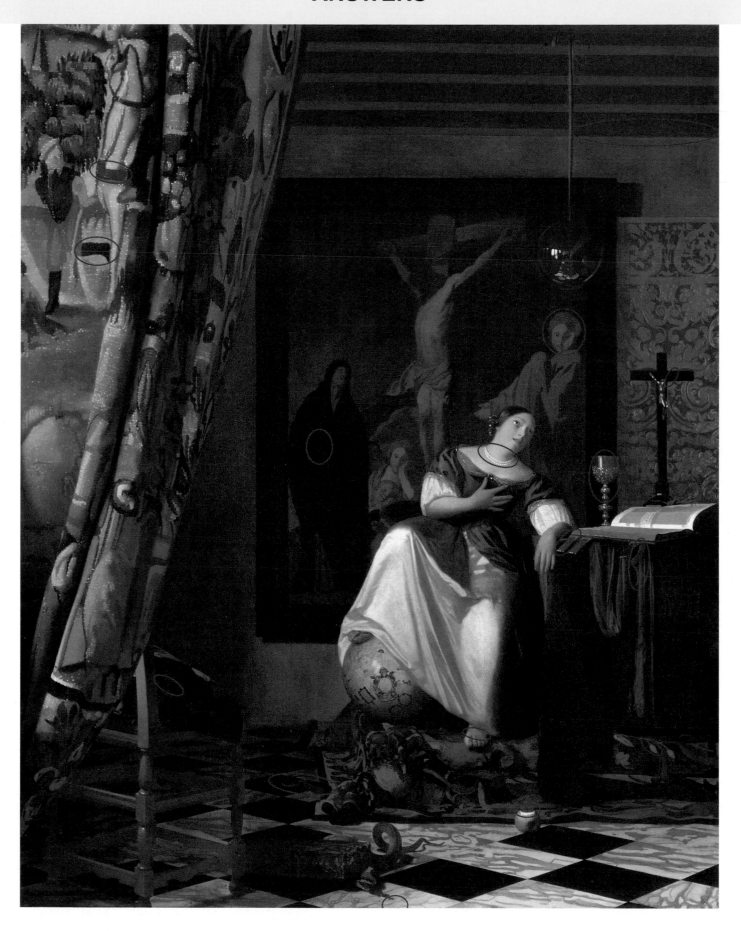

Johannes Vermeer — *The Allegory of Faith*

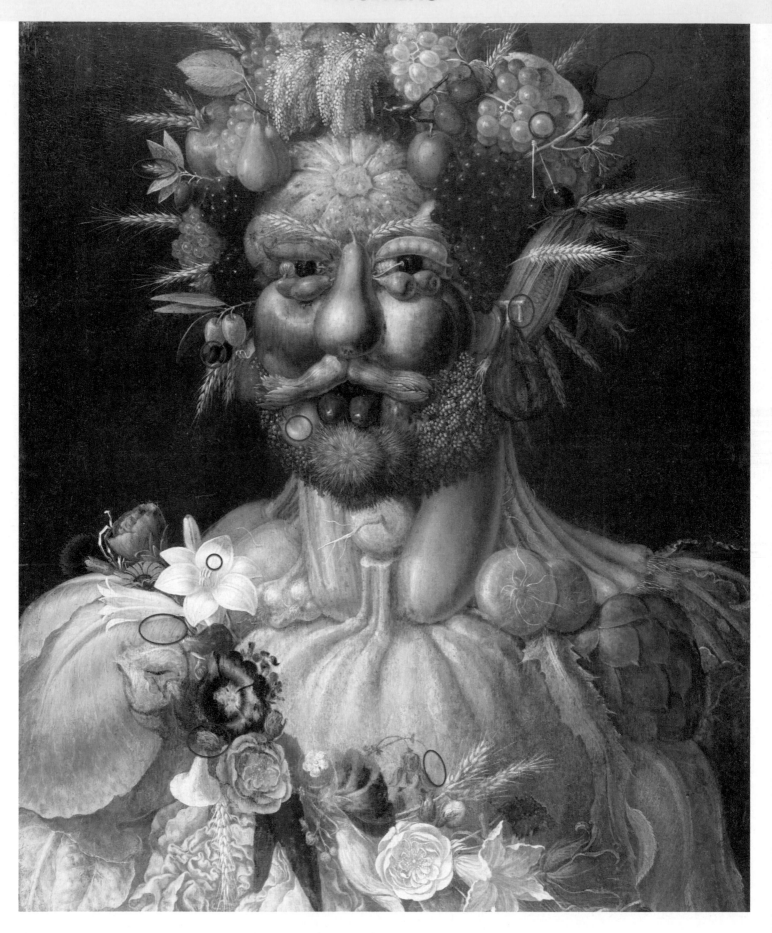

Giuseppe Arcimboldo— *Vertumnus*

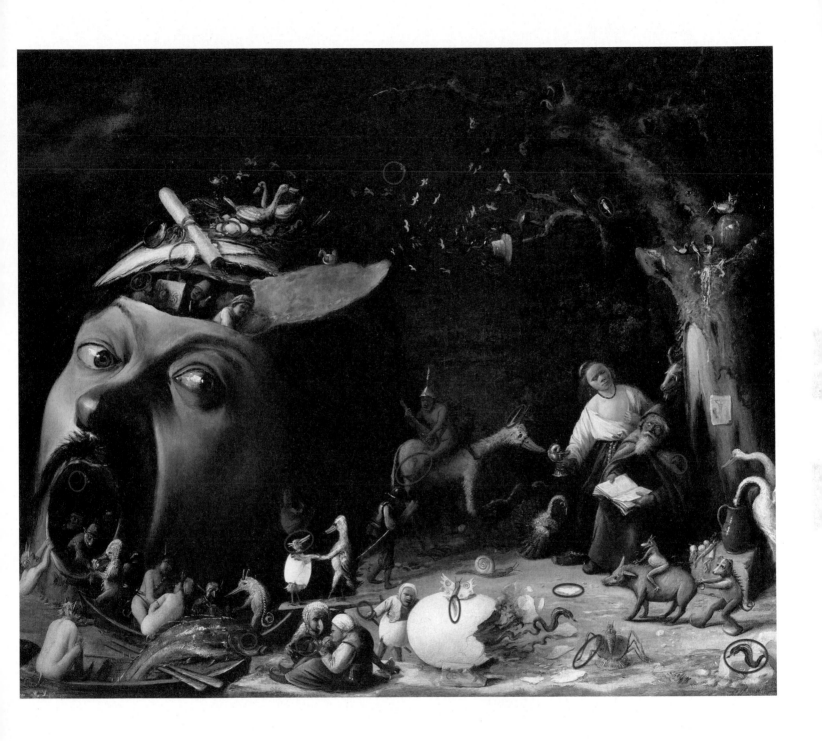

Joos van Craesbeeck—*The Temptation of St. Anthony*

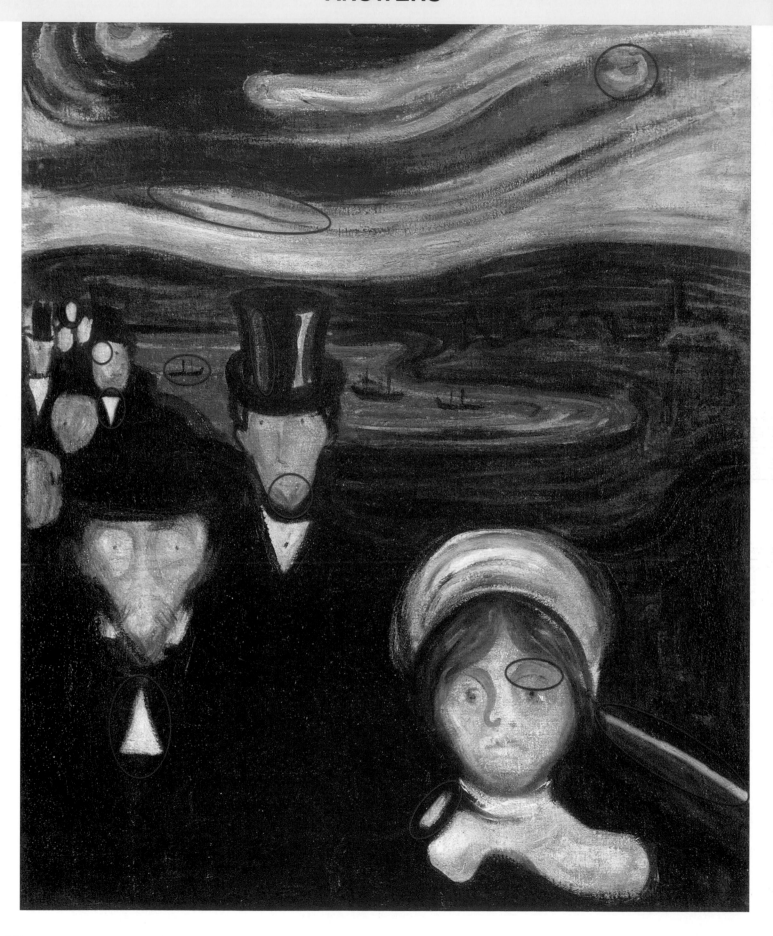

Edvard Munch—*Anxiety*

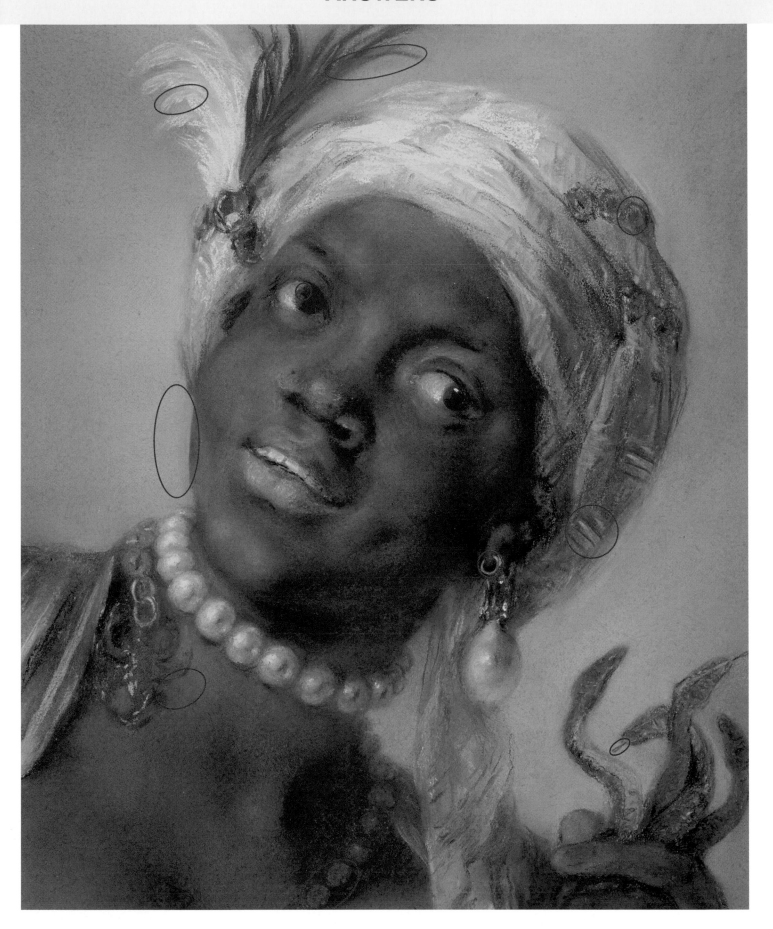

Rosalba Carriera—*Africa*

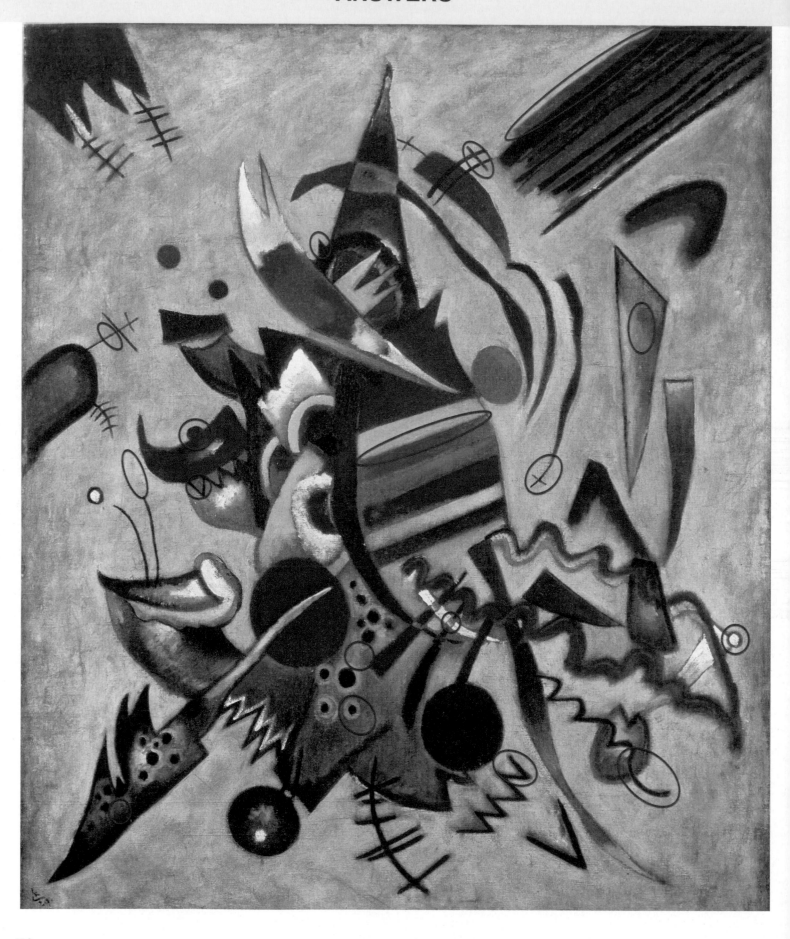

Wassily Kandinsky—*Points*

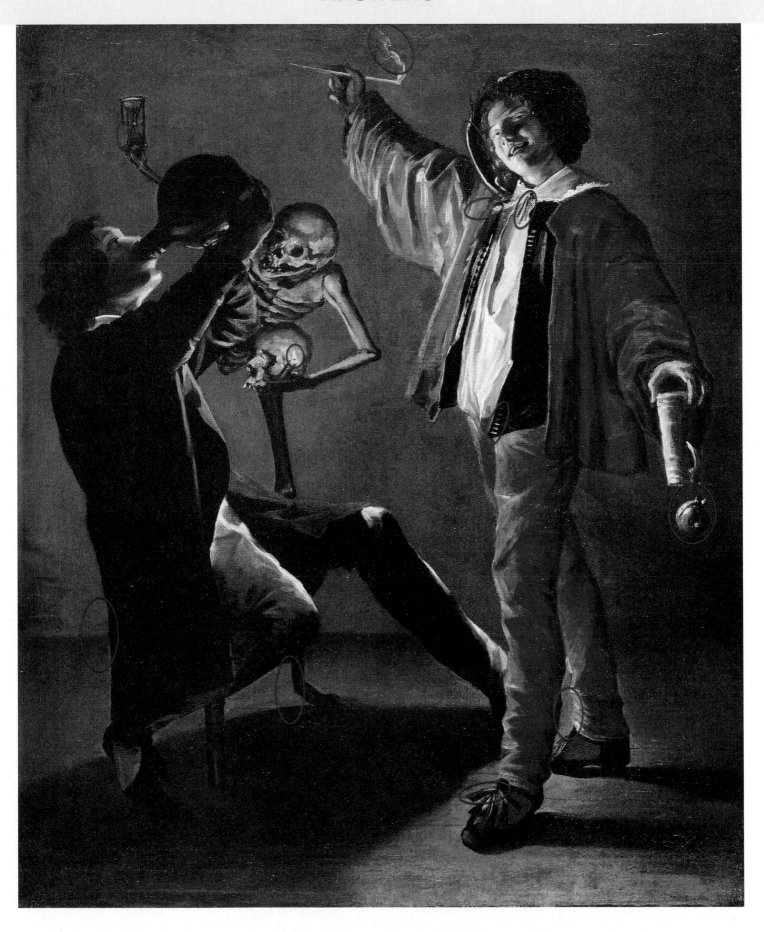

Judith Leyster — *The Last Drop*

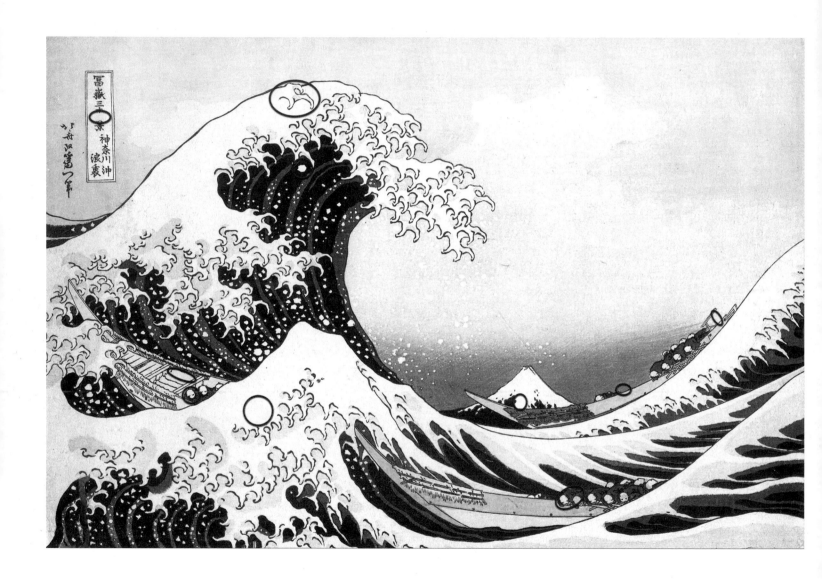

Katsushika Hokusai — *The Great Wave off Kanagawa*

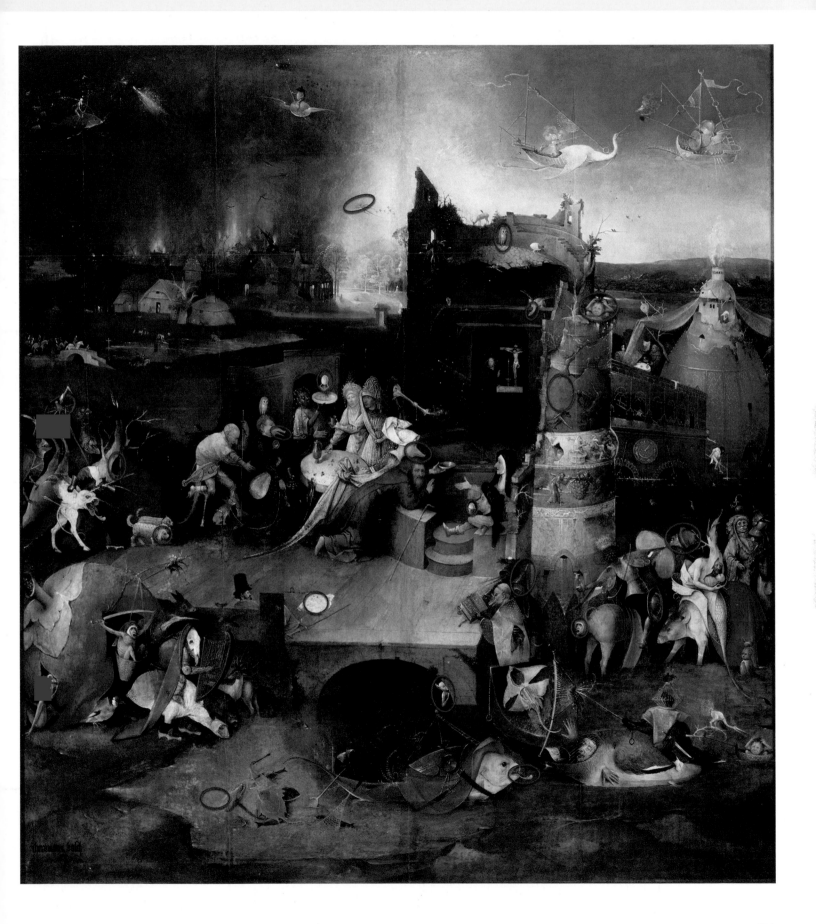

Hieronymus Bosch — *The Temptation of St. Anthony*

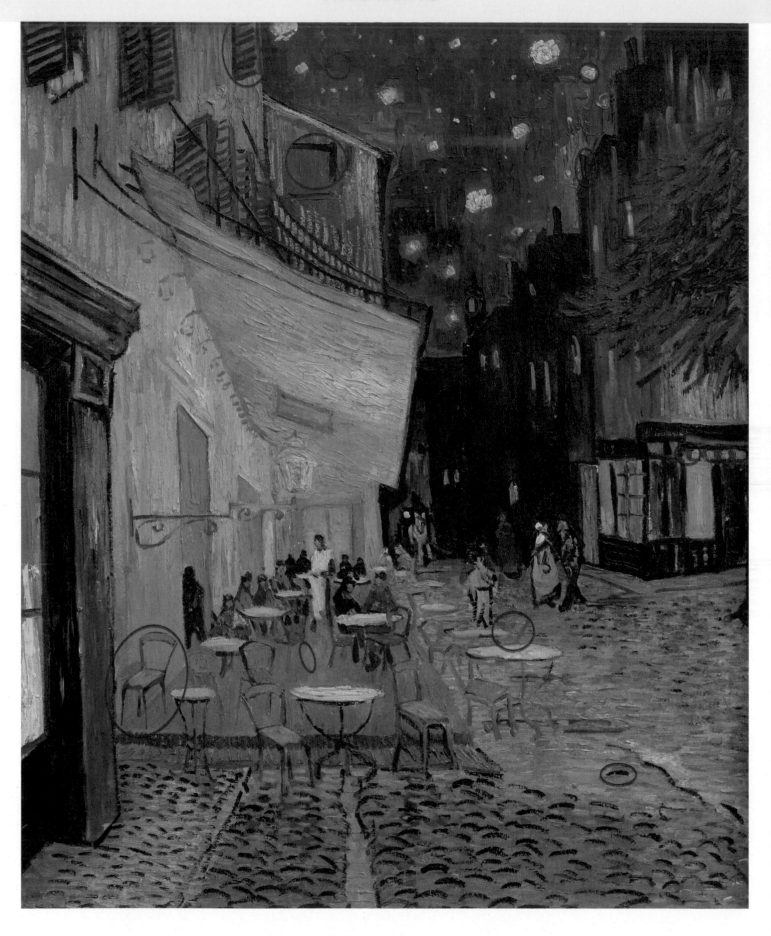

Vincent van Gogh—*Café Terrace at Night*

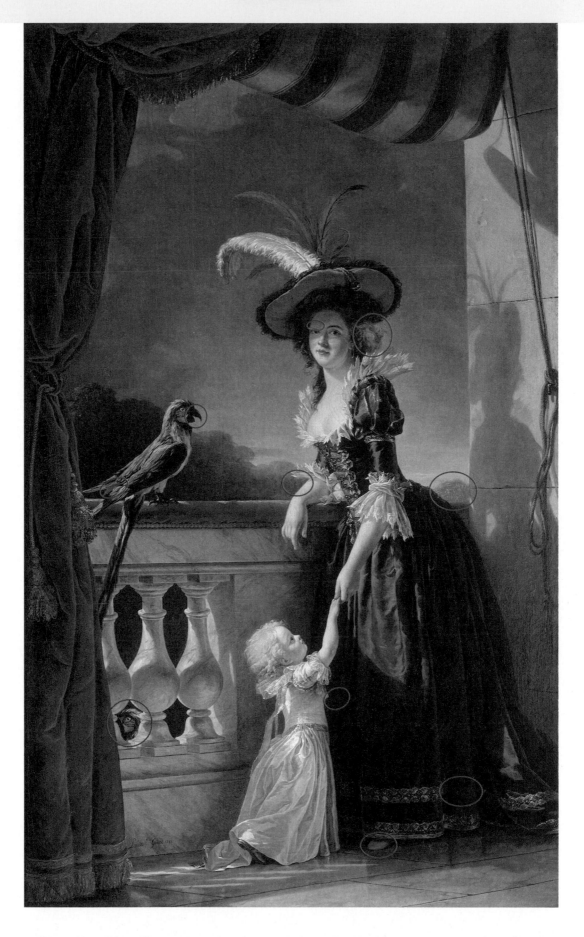

Adélaïde Labille-Guiard—*Mme Louise-Elisabeth With Her Two Year Old Son*

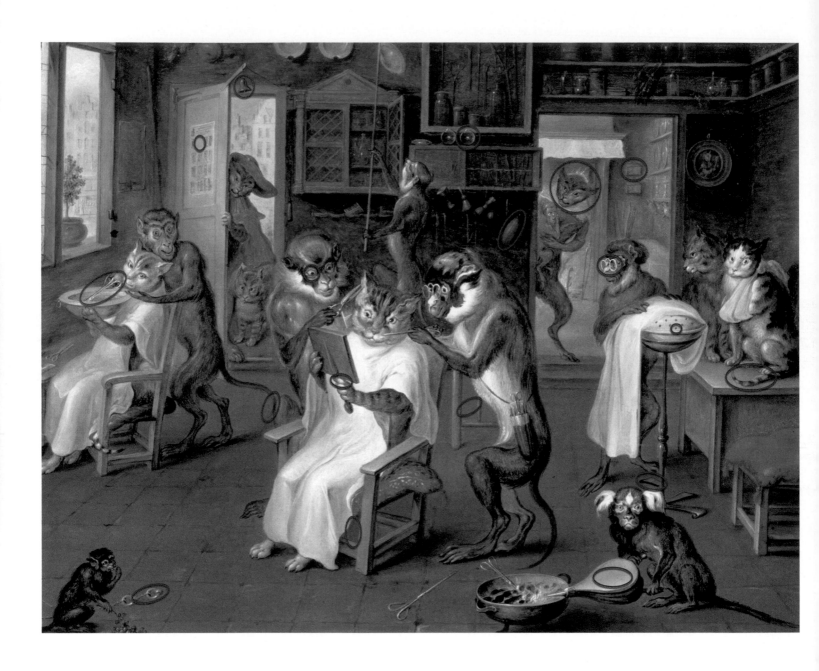

Abraham Teniers—*Barbershop with Monkeys and Cats*

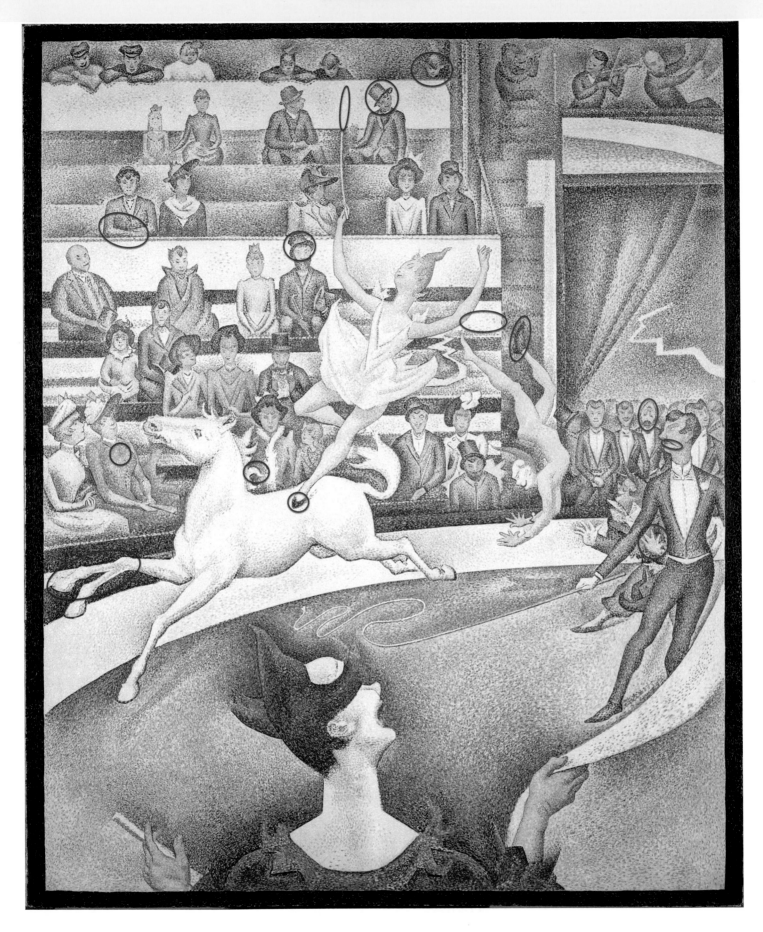

Georges Seurat—*The Circus*

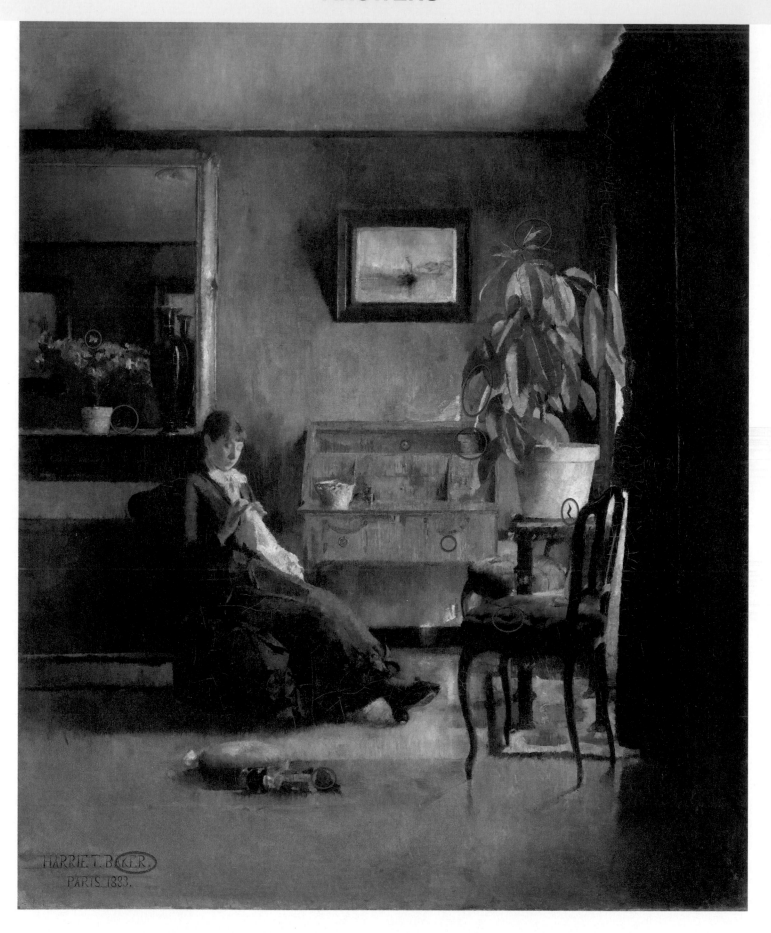

Harriet Backer—*Blue Interior*

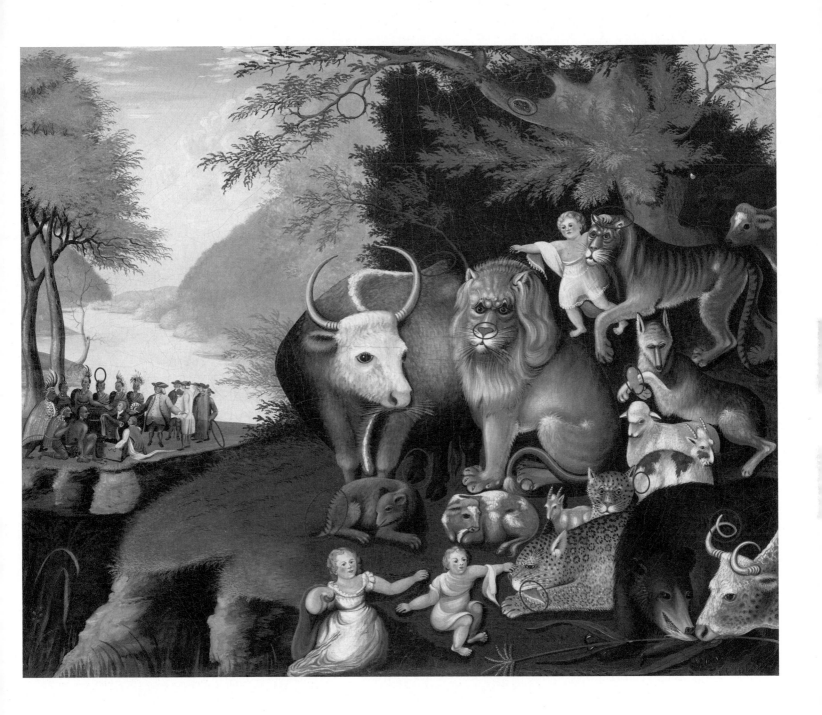

Edward Hicks—*Peaceable Kingdom*

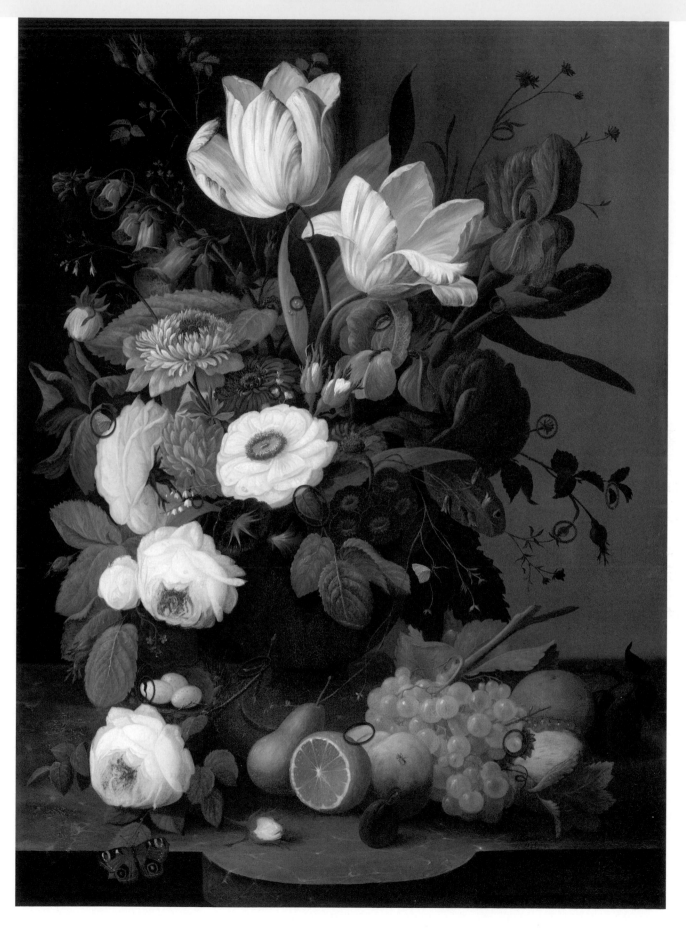

Severin Roesen — *Still Life, Flowers, and Fruit*

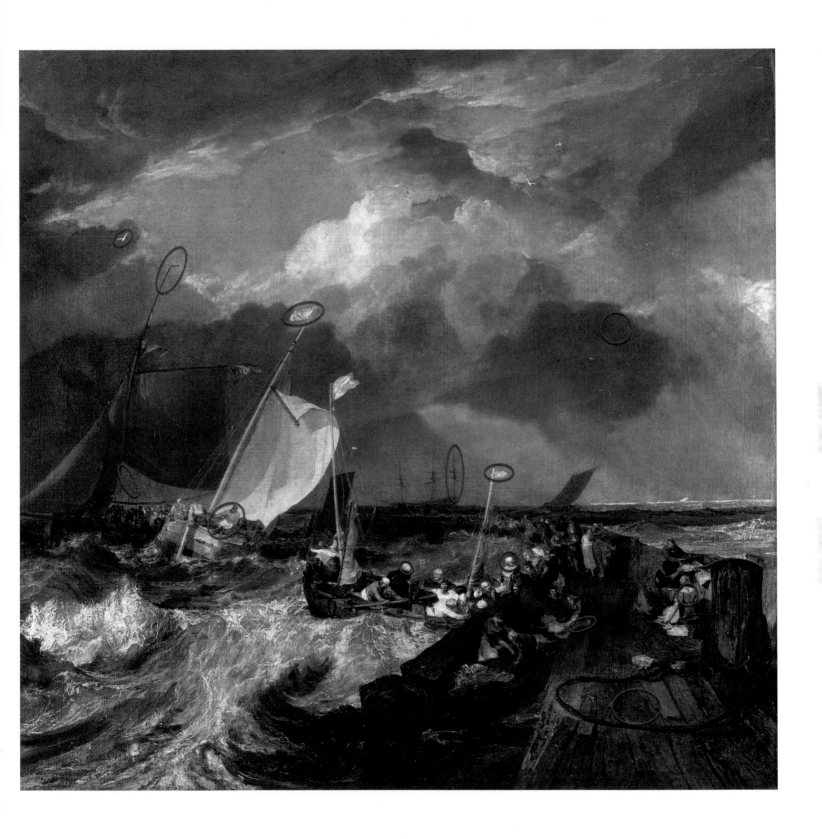

Joseph Mallord William Turner—*Calais Pier*

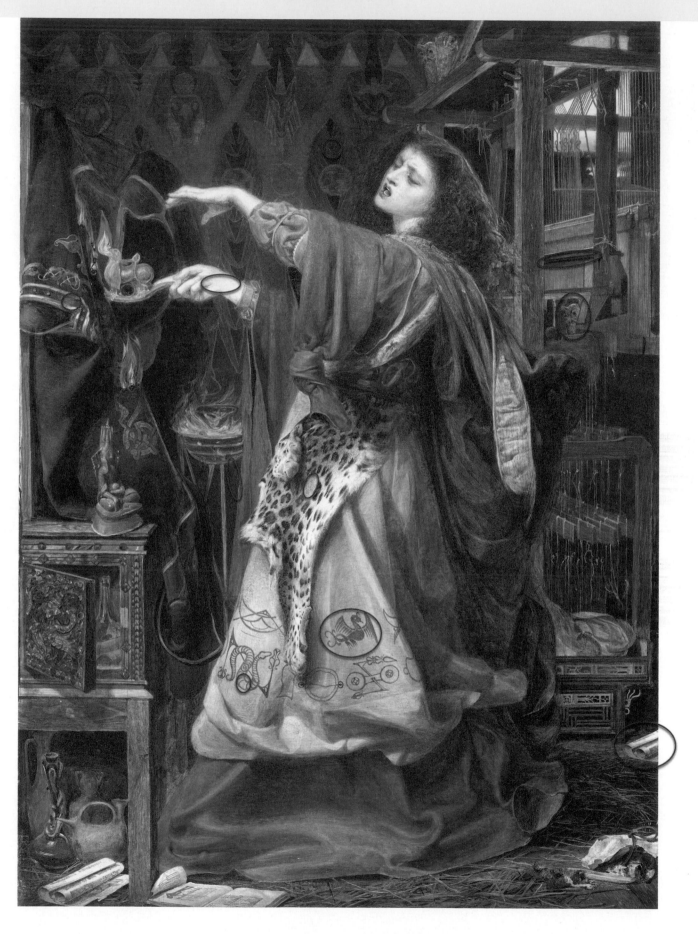

Frederick Sandys—*Morgan le Fay*

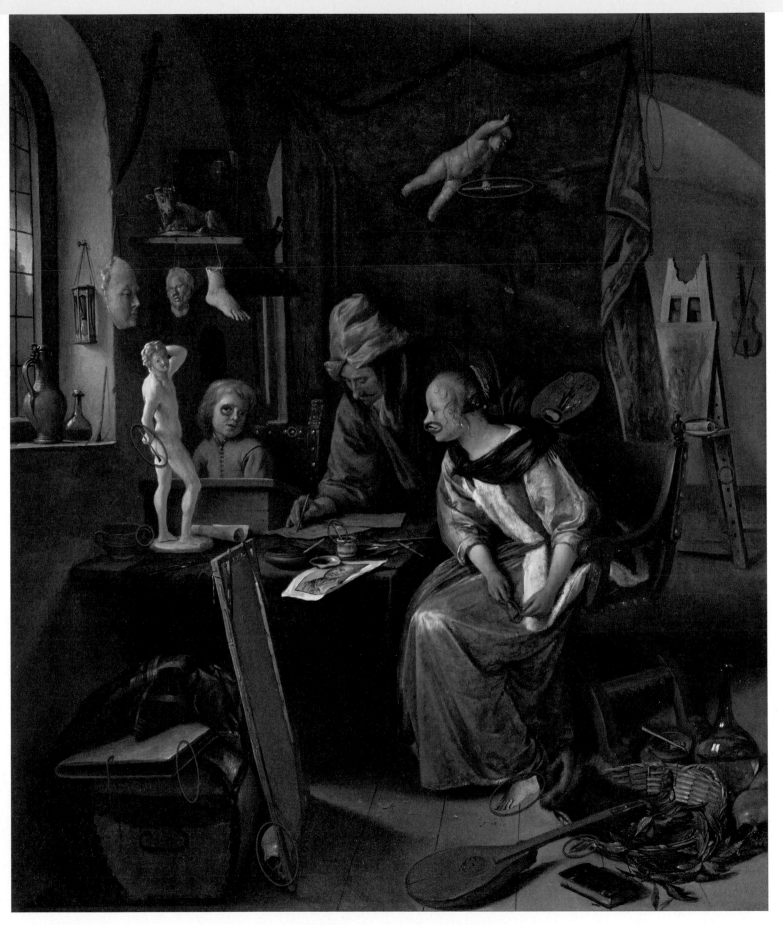

Jan Steen—*The Drawing Lesson*

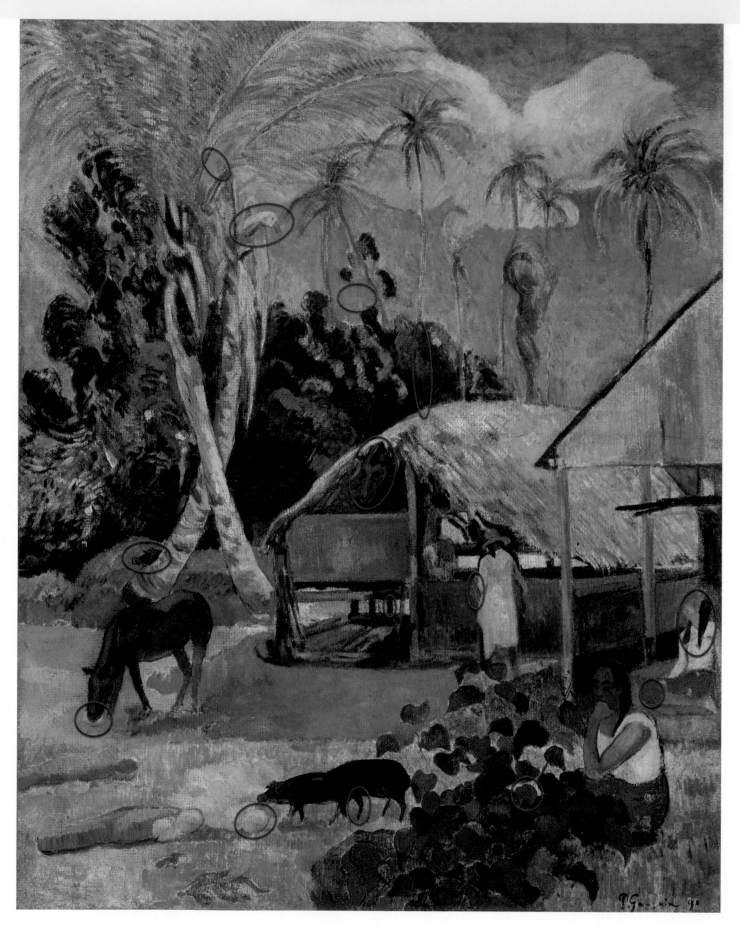

Paul Gauguin—*The Black Pigs*

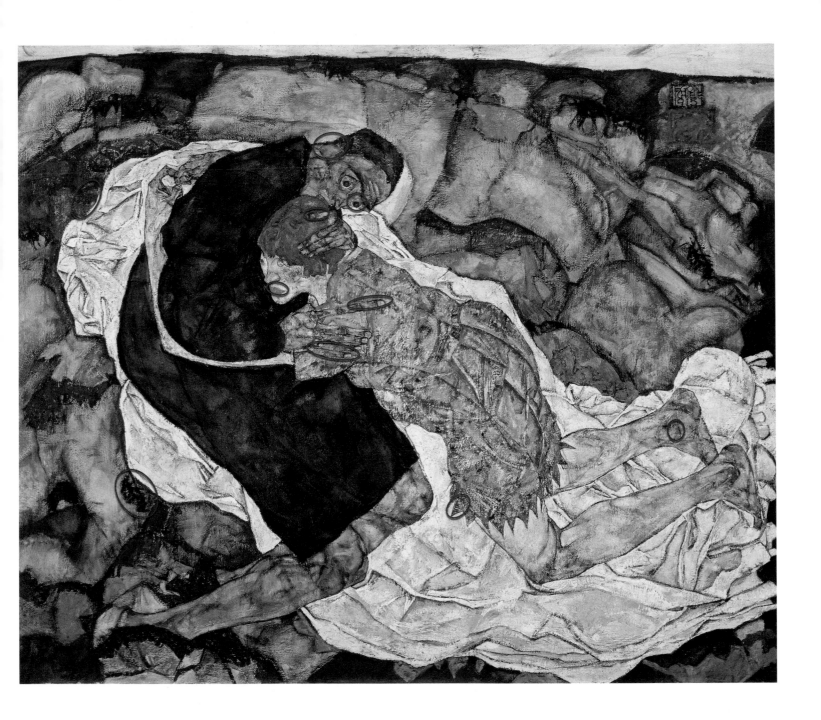

Egon Schiele—*Death and the Maiden*

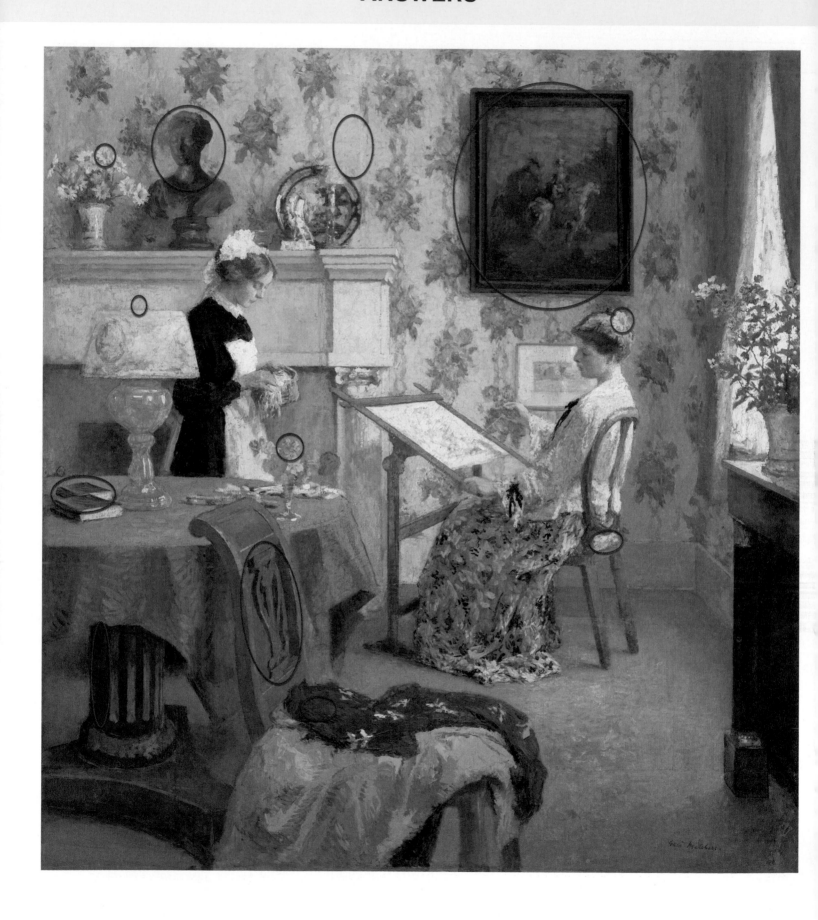

Gari Melchers—*Penelope*

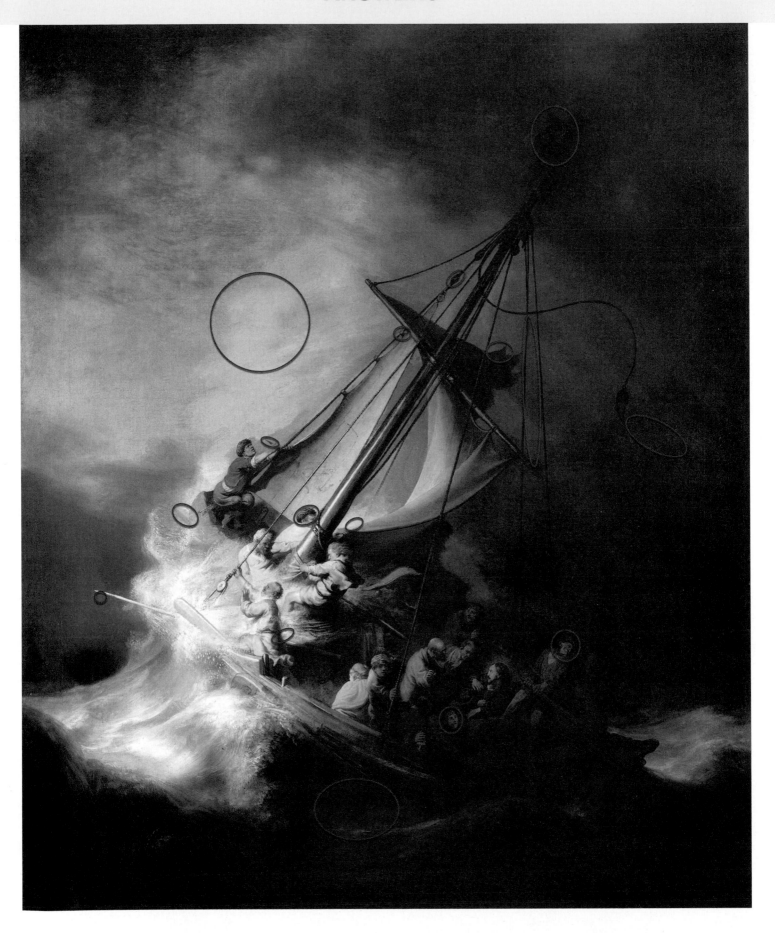

Rembrandt Harmenszoon van Rijn — *The Storm on the Sea of Galilee*

THANKS

Thanks for buying this book and taking the time to spot some differences. I hope it provided some enjoyable entertainment and a chance to see some familiar works of art in a new light.

Thank you to Sarah Jennings, Afshan Ahmad, Vanessa Daubney and the team at Arcturus Publishing for giving me the opportunity to create this book. Researching, curating and modifying these pieces has been a fun and rewarding process, and being able to study each artwork whilst reworking the smaller details has furthered my appreciation for great art and the artists behind these masterpieces.

All artwork has been sourced from The Metropolitan Museum of Art, The National Gallery of Art, Wikimedia Commons and Google Arts & Culture. These platforms have been paramount to the creation of this book, providing an invaluable source of high quality artwork.